THE POTTER'S ART

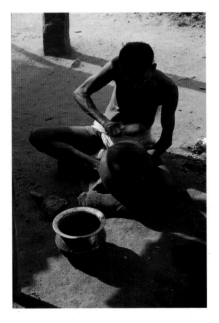

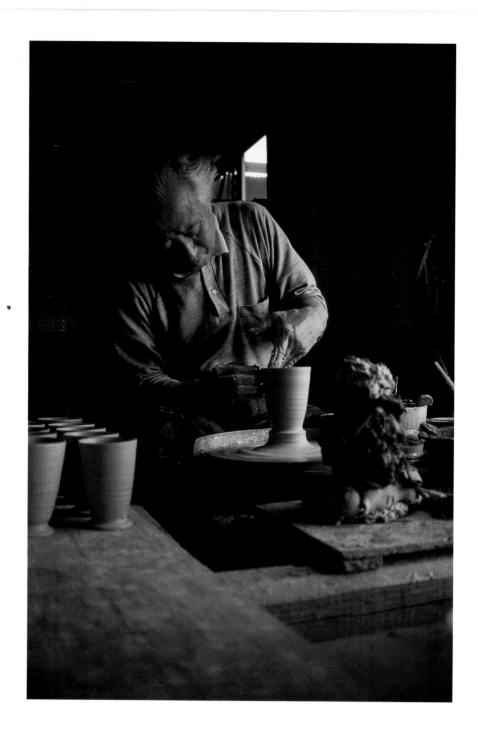

THE POTTER'S ART

Henry Glassie

Photography and Design by the Author

Philadelphia
MATERIAL CULTURE
Bloomington and Indianapolis
INDIANA UNIVERSITY PRESS · 1999

material culture

This is the first in a series of books on material culture, co-published by Material Culture of Philadelphia and the Indiana University Press, edited by George Jevremović, William T. Sumner, and Henry Glassie.

The Potter's Art is an expanded revision of the fourth chapter of Henry Glassie's *Material Culture*, published by the Indiana University Press in 1999.

The frontispiece shows Norio Agawa at work in Hagi, Japan, in 1998. The photographs are explained in the Notes, beginning on p. 133.

Indiana University Press
601 North Morton Street
Bloomington, Indiana 47404-3797 USA

www.indiana.edu/~iupress

Telephone orders 800-842-6796
Fax orders 812-855-7931
Orders by e-mail iuporder@indiana.edu

Material Culture
4700 Wissahickon Ave., Suite 101
Philadelphia, Pennsylvania 19144 USA

www.materialculture.com

Telephone 215-849-8030
Fax 215-849-5535
E-mail info@materialculture.com

The paper used in this publication meets the minimum requirements of American National Standard for Information Sciences — Permanence of Paper for Printed Library Materials, ANSI Z39.48-1984.

Manufactured in China

Library of Congress Cataloging-in-Publication Data

Glassie, Henry H.
 The potter's art / Henry Glassie ; photography and design by the author.
 p. cm. — (Material culture)
 "Expanded revision of the fourth chapter of Henry Glassie's Material culture, published by the Indiana University Press in 1999"—T.p. verso.
 Includes bibliographical references and index.
 ISBN 0-253-21356-8 (pbk. : alk. paper)
 1. Pottery Cross-cultural studies. I. Title. II. Series: Material culture (Indiana University, Bloomington)
NK4235.G54 1999
738'.09—dc21 99-37064

1 2 3 4 5 04 03 02 01 00 99

CONTENTS

The Potter's Art 17

Bangladesh 19

Sweden 34

Georgia 36

Acoma 48

Turkey 56

Japan 91

Hagi 98

Work in the Clay 116

Acknowledgments 123

Notes 125

Bibliography 139

Index 145

for my friends,
the stars of Kütahya,

İbrahim Erdeyer • Mehmet Gürsoy
Kerim Keçecigil • Sıtkı Olçar
Ahmet Hürriyet and Nurten Şahin

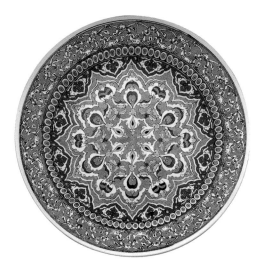

THE POTTER'S ART

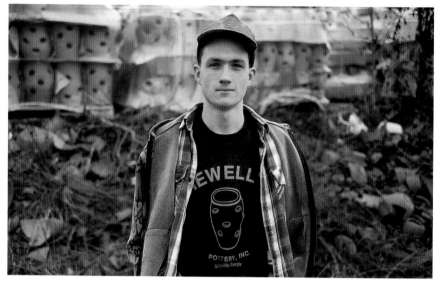

Matthew Hewell. Gillsville, Georgia. 1994

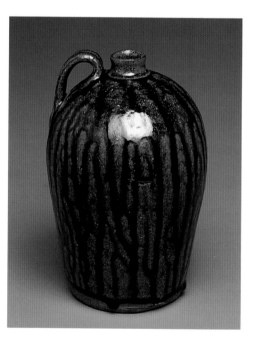

Jug.
By Matthew Hewell.
Gillsville, Georgia.
1993

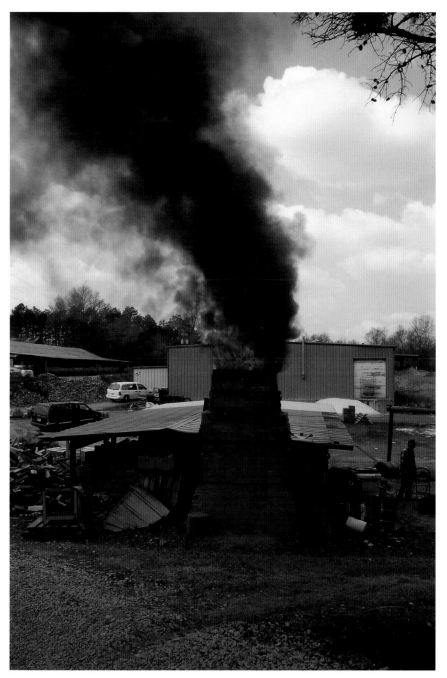

Firing the kiln. Hewell's Pottery.
Gillsville, Georgia. 1999

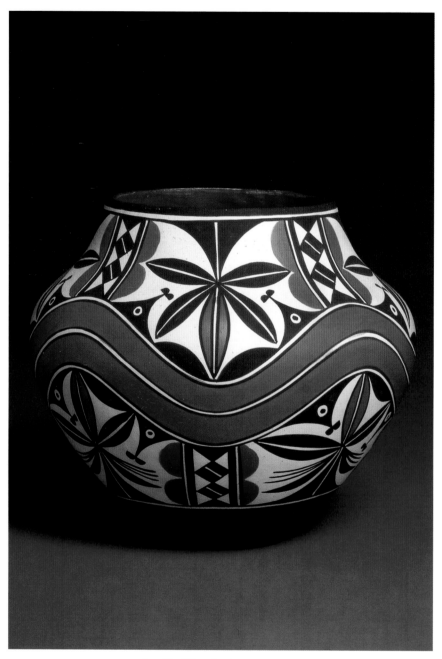

Jar. By Wanda Aragon.
Acoma, New Mexico. 1996

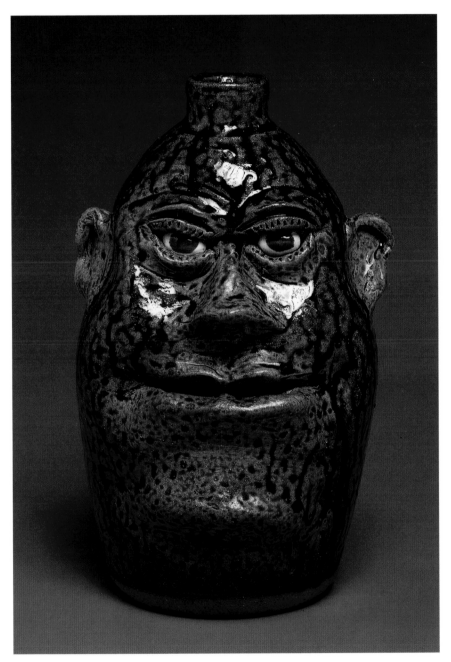

Face jug. By C.J. Meaders.
White County, Georgia. 1999

Vase. By Norio Agawa.
Hagi, Japan. 1998

Bottle. By Hirohisa Tatebayashi.
Arita, Japan. 1994

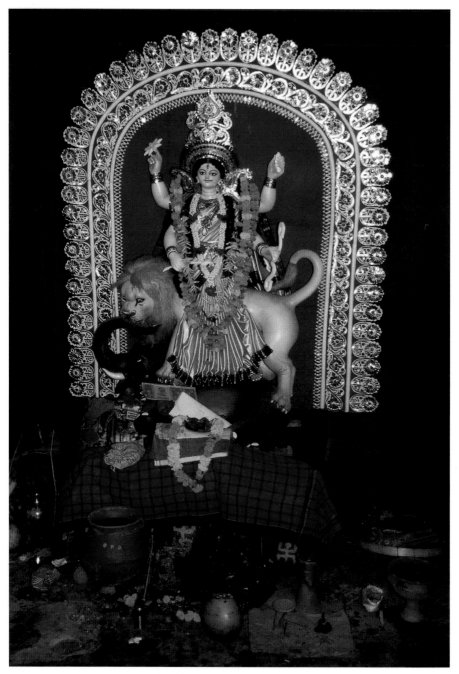

Jagadhatri. By Haripada Pal.
Dhaka, Bangladesh. 1998

Haripada Pal. 1998

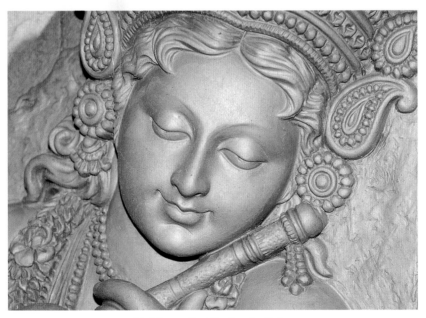

Krishna. By Haripada Pal.
Dhaka, Bangladesh. 1995

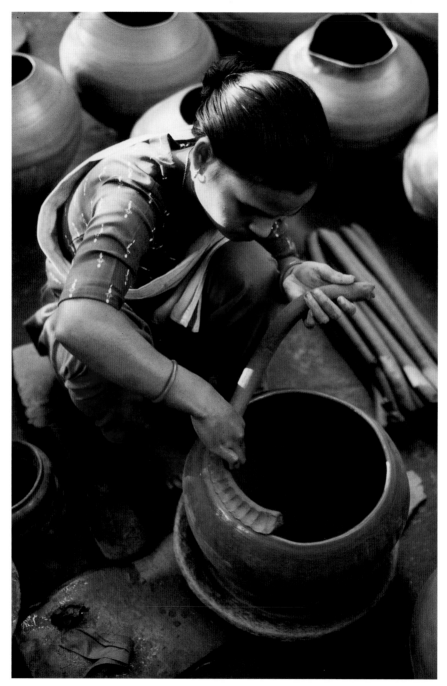

Malati Rani Pal at work.
Kagajipara, Bangladesh. 1989

THE POTTER'S ART

POTTERY IS THE most intense of the arts. It brings the most to bear within the smallest compass.

Pottery makes plain the transformation of nature. Clay from the earth blends with water from the sky. The amorphous takes form in the hands. The wet becomes dry in the air. The soft becomes hard and the dull becomes bright in the fire. Cooked, the useless becomes useful.

Pottery works in the world. Displaying the complexity of the human condition, it brings the old and the new, the personal and the social, the mundane and transcendent into presence and connection.

In pottery, in all art, there must be destruction. The earth is ripped open to reveal the materials of creation. In creation, there must be cooperation. People go up to the mountain and down to the riverside. They gather and refine the yield of nature, dividing the tasks, teaching, learning, and joining in work. In work — if there is to be art — there must be concentration, an instant of aloneness, a moment of devotion when the self is given, sincerely and completely, into new things that reconfigure the field of existence.

Coming into being, the work of art, this very pot, creates relations — relations between nature and culture, between the individual and society, between utility and beauty. Governed by desire, the artist's work answers questions of value. Is nature favored, or culture? Are individual needs or social needs more important? Do utilitarian or aesthetic concerns dominate in the transformation of nature?

Art disturbs nature to embody values. The more values that a creation contains, the richer its display of purpose, the more it is to be addressed as a work of art. Attitudes in the ambit of art imply value. Art is gauged in economic terms: the object's worth as art is established in the gap between its price and the cost of its materials. It is judged philosophically, the object's worth lying in its ability to provoke and sustain argument. Veneration divides things: this one is used hard and discarded, that one is dressed with the blood of sacrifice or reverently elevated on a pedestal in an atmosphere controlled for heat and humidity. Works of art bring cash, inspire discourse, and request respect, but their inherent worth does not depend on response. It abides in the gift made to them by their creators. Artists dedicate themselves to their work, bearing down in concentration, and the things in their hands fill with the human and swell with value.

One way to describe the study of art is to say that it is the process of discovering through objects the values of their makers and users. In the ethnographic study of art, I have found, it is wisest to attend to the full range of media, noting how values obey and ignore the limitations of craft disciplines while people express themselves and shape their culture. But in cross-cultural study, the conventional art-historical focus on media bears merit. We can hold the medium steady, learning how people who are biologically alike use the same materials and similar techniques to realize cultural difference and human unity.

The chief problem in the study of art is learning to value the unfamiliar. Born into an environment full of pictures, trained to understand how paintings contain value, it is natural for us to travel the world with the framed painting in mind. Then, encountering other people and assuming their traditions to be like ours, we tend to miss their best effort altogether and select their minor works because of a fancied resemblance to our own. We welcome other people into study only to dismiss them as inept makers of pictures and affirm our superiority. But no matter how important the easel painting is in the late West, it is uncommon

in world history. It would be more just, truer to reality, to begin with textiles and ceramics, neolithic victories that are genuinely global in distribution. The result would be chastening. The industrial West would not fare so well — we have no textiles to match Iran's, no pots to match Japan's — but we would be closer to comprehending the human urge to excellence.

This book is composed of a few stories about the potter's art. Its goal is to illustrate how common clay is made to carry value.

Bangladesh

I will begin on the other side of the world, in Bangladesh. The land is lush and flat. Through it rivers run from the mountains to the sea. Their silt has built the world's widest delta. Having much money, we grade the world's nations by wealth, and Bangladesh lies near the bottom, but if clay were the basis for ranking, Bangladesh would stand at the top. It is a beautiful green place, rich in clay.

The very earth is the common resource upon which life is built. Farmers plow the fertile soil and plant it to rice so that people might eat. The clay beneath the surface is dug out, borne in headloads, and heaped into foundations to lift the villages above the flood. And clay is mined and mixed, shaped and baked into the tools that people use to get through another hard day.

In Bangladesh, there are six hundred and eighty villages of potters, nearly half a million people who use clay to make art because clay is what there is. The nation is predominantly Muslim, but the potters are predominantly Hindu, members of the craft-caste of the Pals. Potters — Pals — divide themselves into two kinds. One kind, they say, makes *kalshis*, the other *murtis*.

The *kalshi* is a globular water jar, but makers of *kalshis* make utilitarian pots of all kinds — vessels for cooking food as well as carrying water. Symbolized by the elephant, water is a terrible force in the delta of Bengal, bringing life in rain, death in flood,

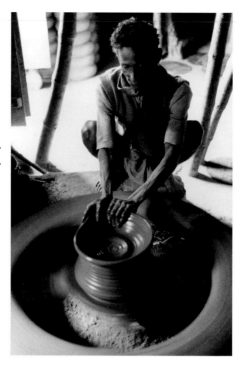

Gauranga Chandra Pal.
Rayer Bazar, Dhaka.
1995

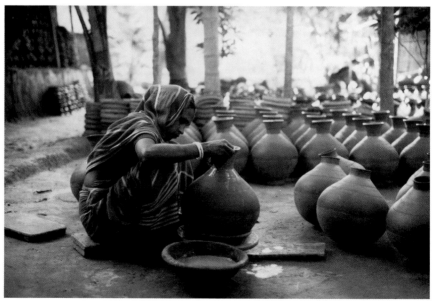

Parul Rani Pal making *kalshis*.
Kagajipara, Dhamrai, Bangladesh. 1988

and the potter's prime creation is the one capable of containing water, the *kalshi*.

They begin by blending two kinds of clay — one black and sticky, one white and sandy — into a smooth new substance. Then, women and men use different techniques to accomplish identical forms. Women raise the *kalshi* in a sequence of three dishes, turning them by hand, while adding coils to fashion the shoulders, neck, and lip. Men use the big *chak*, the hand-powered wheel that requires postures unbecoming to women. They throw the *kalshi* in two sections, then paddle the parts into unity. The goal is to achieve the maximum of internal volume, and the minimum of weight, while crafting a thin-walled jar for the transport of water. The need is real, and it has long endured. Terra cotta tiles nearly two thousand years old show *kalshis* in the modern form being carried by women in the way they are carried today, with an elbow crooked around the neck and the body of the pot pressed into the hollow of the waist.

Fired on an open, wood-burning kiln, the *kalshi* becomes a commodity. It is made to sell. It is bought to use. In commercial exchange, potters get cash, customers get tools, and they join in a bond of interdependence and trust, founded upon the honorable ethic of utility.

Among the Pals, most men and women make *kalshis*. In the villages I know, one household out of ten contains men who make *murtis*, images of the deities for worship. They begin with a prayer, repeating a mantra of praise to the deity that calls a vision into the mind. As the artist of realism works to render an image that registers on the retina, the sculptor of *murtis* strives to realize a direct revelation of the divine that appears to the mind's eye. He splits sticks to build a frame, wraps it with rice straw, bound into form, and then covers the straw with a thick coat of the clay blend used to make *kalshis*. Next comes the time of concentration, when the *murti* is detailed to completeness through sprigging and modeling by hand.

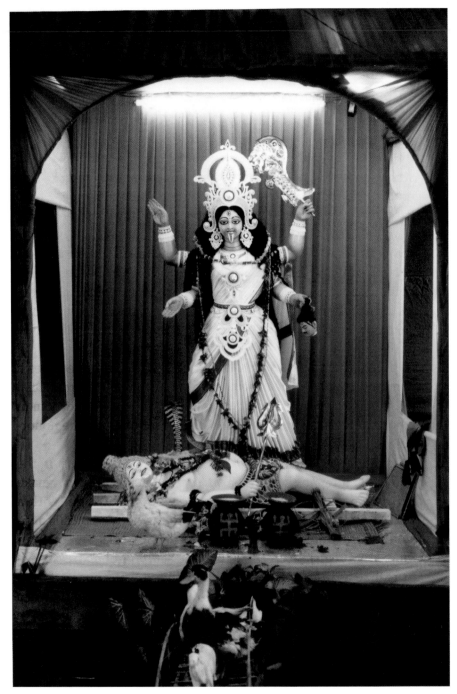

Kali steps on Shiva. Shama Puja.
Tanti Bazar, Dhaka, Bangladesh. 1998

In the moment of concentration, as the sculptor Haripada Pal describes it, the artist withdraws from the quotidian. "Many times I become so devoted to my work," Haripada said, "that I feel no other one around me, and I unite with God. Sometimes I become part of God. Sometimes God becomes part of me. I feel God in myself when I concentrate."

Called Bhagaban, called Allah, God is omnipresent and formless. God follows prayer into the mind in the form of a particular deity.

The deities each have their powers, their missions. First is Devi, the Great Goddess, manifest as Durga in triumph and Kali in rage. She is the Great Mother, attended in worship by her children: Saraswati, the goddess of wisdom; Lakshmi, the goddess of wealth; Kartik, the beautiful god of war; and Ganesh, the Lord of Beginnings, with his opulent paunch and white elephant's head. Next is Shiva, called Mahadev, the Great God. He rises in pure energy as the phallic, black Linga. He dances alone, his dreadlocks flying; in one hand, he holds the drum that sets the tempo of existence, in another burns the flame that will extinguish the world at the end of its current phase of misery. Shiva embraces Devi in her wifely embodiment as Parvati. He lies, a dozing dandy, beneath the feet of Kali. Third of the great deities is Vishnu, the Lord of Life. In devotion, Vishnu is eclipsed by Krishna, his eighth avatar, the third incarnation of time, who sways with his lover, Radha, and lifts his flute to call humanity to love. And there are others: Bishwakarma, the god of the artisans; Sitala, the goddess of smallpox; Manasa, the goddess of snakes. Out of the infinite, the deities coalesce to give form and special purpose to the single power of God.

God fills the mind with living form, and in working to recreate his vision in clay, the artist becomes a conduit for universal power. The clay in his hands contains the seed of all creation, the presence of God that springs to life with prayer. The clay of his body contains the immortal soul, the drop of God that enables all action. During creation, at one with God, working to pull God's image out of God's substance, Haripada Pal caresses and

massages the clay, pressing into its softness, while the power in his body surges through his fingertips to fuse with the seed of creation, effecting a reunion of the divine and impregnating the image with sacred force. Haripada says that his work in the clay is part of his devotion to God. It is a prayer.

As I watched Sumanta Pal, sculptor in the village of Kagajipara, create a *murti* of Saraswati, the goddess of wisdom, I saw how his every motion was pitched toward perfection. His steady hands, trained to repetition in common work, figured pieces into neat patterns. His mind, capable of seeing the form beyond the form, brought shapes into singing symmetry. Sumanta's Saraswati swells with fecund youth like the wooden gods of Africa. There is no sign of age or strain, no tug of gravity. She is weightless, inflated with power and radiant with beauty. The abstract and idealized qualities in Sumanta's statue — qualities found generally in what is called folk art — do not eventuate from a failed effort to depict a woman out of the world. This is a goddess. Sumanta's work is a prayer, its result is a splendid materialization of eternal power.

The aesthetic of the *murti* is built upon the sacred and oriented to the transcendent. Nature's implicit patterns and geometry are extracted and brought to perfection in manifest symmetries. Nature's roughness is erased in smooth, dampened and sanded layers of fine clay. Nature's dullness, the dark tone of the earth, is hidden by a coat of white paint, thickened with boiled tamarind seeds, that serves, like the gesso of the carved Latin American saint, to seal the surface and provide a bright base for the application of luminous color.

The *murti* is not burned. Fire would kill the power of the clay that abides in its dampness. The damp interior is for power. The surface — symmetrical, smooth, and bright — is for beauty.

Powerful and beautiful, the *murti* makes sacred wisdom visible. Haripada Pal was trained in his art by his grandfather Niroda Prasad Pal, and he was instructed in esoteric interpretation by a saintly ascetic, Surendra Chandra Sarkar. He knows one hun-

Basanta Kumar Pal,
shaping the straw form
for an image of Saraswati.
Kagajipara, Dhamrai, Bangladesh.
1998

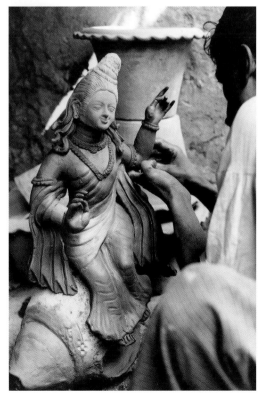

Sumanta Pal,
sculpting a *murti* of Saraswati.
Kagajipara. 1995

dred and eight distinct images of Kali, the goddess in wrath. They are brought to order in myth.

In the story Haripada tells, beautiful Kali — black in color to her enemies, the blue of the deep sky to her devotees — set out to destroy the evil in the world. But with her success, in the midst of her rage, she lost the difference between good and evil. Wielding the sword in her left hand, she began to destroy everything. In terror, the people went to Lord Shiva, beseeching him to do something. Shiva positioned himself in her path and fell asleep. Continuing on her wild course, Kali stepped on him. Her foot knew Shiva's flesh. Her tongue lolled in shocked embarrassment and sudden understanding. Recognizing the wrong she had done by putting her foot on her husband's body, she remembered her duty to him. Particular understanding became general: the sword switched from her left hand to her right as a sign of her recognition of the wrong she had done to the world, and of her duty to humankind. It is Kali in this instant, her foot on Shiva, her tongue hanging, that Haripada shapes of clay. His statue embodies a narrative. It carries myth and wisdom, and it is poised for ritual.

Kali is caught in the flash of awareness. With the sword in her left hand, she is Shamakali, strong and enraged. Her devotee asks for protection, praying for the annihilation of the devils in the world, the criminals and terrorists who make life miserable. With a sword in each hand, in the midst of transition, or in her right hand only, a split instant later in mythic time, she is Rakshakali, strong and benign. Her devotee asks for personal blessings. This is the Kali, Haripada says, that people can approach with prayer, offering gifts and requesting worldly favors.

Haripada Pal calls the *murti* a mediator. It is made to bring people toward God so their lives will improve. The beauty of the *murti* works like a litany of praise to attract the deity into the clay, as the artist's mantra called the deity into his mind. The beauty of the *murti* draws people toward the deity so that they can communicate with God.

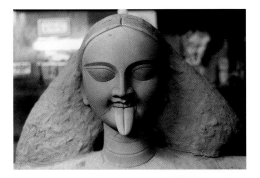

Rakshakali.
By Haripada Pal.
Shankharibazar, Dhaka.
In process, 1998

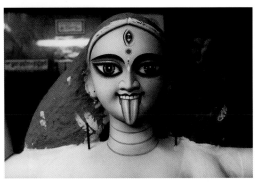

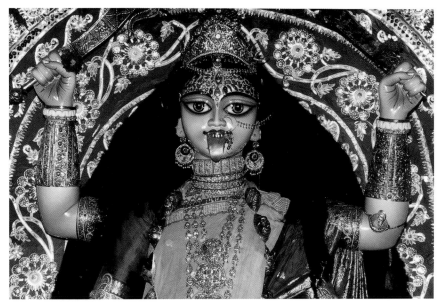

Rakshakali. By Haripada Pal.
Shankharibazar Kali Mandir. Dhaka, Bangladesh. 1995

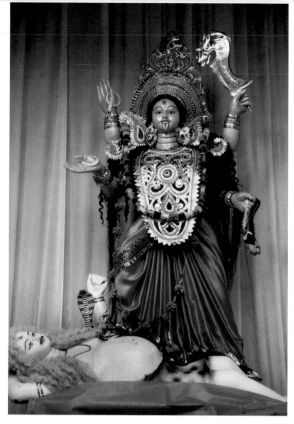

Shamakali.
By Haripada Pal.
Shama Puja.
Shankharibazar,
Dhaka. 1998

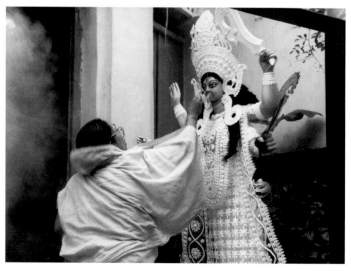

Kali is fed before her sacrifice.
Shama Puja. Tanti Bazar, Dhaka. 1998

On the day set in scripture, the *murti* is installed in a tented pavilion. Invited by prayer, pleased with the beautiful image prepared to receive her, the goddess descends into the clay. The *murti* is made to signal from afar, obliterating the distance that divides people from God. The large eyes in the large head pull the people, and they crowd forward, straining to take *darshan*, connecting eye to eye with the goddess. Their eyes meet: the water in the clay of the body of the devotee connects with the water in the clay of the body of the *murti*; the soul in the devotee connects with the goddess in the statue. Contact is made, communication becomes possible. While the deity is delighted with throbbing drums and dancing flames and the sweet smell of incense, people make their wishes known to the goddess. In sacred exchange, they give flowers and receive sweet cakes and fruit, palpable, consumable signs of wishes to be granted.

With the cool light of dawn, worship ends. The goddess is gone, the beautiful statue is empty. Practice differs for each deity. Worship lasts seven days for Durga, one day for Saraswati, then after a week in the case of Durga, a year in the case of Saraswati, the painted *murti* is fed, garlanded, and borne to the river in a jubilant, carnivalesque procession. Incense fills the air, the drums pound, and at last, to the ululation of the women, the image is drowned, melted back into the running water from which it came. The clay of the *murti* decays into the silt out of which the *kalshis* and *murtis* of the future will be shaped. The rivers go on flowing, the cycles of birth and rebirth, of creation and sacrifice, continue.

In the contemporary United States, ceramic artists divide. Some make utilitarian vessels, others make sculpture, and the difference between them can stiffen into contention. But the potter in Bangladesh creates both useful ware and lovely statues. They say that some make *kalshis* and others make *murtis*, but in practice most of the Pals who work in season to sculpt icons of the deities fill slack time with the manufacture of utensils of clay.

The separation of *kalshis* from *murtis* seems to align with the Western division of craft from art. Western critics sunder the utilitarian from the aesthetic and pose them in opposition, demeaning work and lifting some artifacts with some people into an idle elite. But most people work; it is their lot, their burden, their delight, and they appreciate help during the labor of their days. For the world's working majority, utility is a high value, the merely decorative seems trivial, and their greatest creations blend the aesthetic with the useful, just as the good meal blends flavor and nutrition. The potters of Bangladesh make useful pots and beautiful statues, and they call them both *shilpa*: art.

Murtis lift the sacred to view in beauty. The *kalshi* is for use. And yet the *murti* and *kalshi* share in affect. Both are symmetrical, smooth, and bright. Like the *murti*, the *kalshi* is pulled away from nature during creation. It is raised to geometric form, its surface is fastidiously smoothed, and it is slipped. The slip, a solution of special clay, serves no utilitarian purpose. It sheathes the pot with color and sheen.

If holes are poked through the coating of straw and mud that covers the pots on the kiln, the *kalshi* comes buff from the fire, and its surface glows with the rich red of the slip. If the fire is smothered, an atmosphere of reduction is established, and the *kalshi* emerges blackened from the kiln. Slipped passages shine, the surface plays from silver to sooty black. And the *kalshis* were stacked on the kiln so that the proximity of other pots would produce pale clouds on their sides that are desirable marks of beauty to their makers and their buyers.

Utility dominates, but much time is given to making the *kalshi* handsome as well. Trim rows of dents are hammered around the shoulder to ornament the pot, to clarify the impurity of its commitment to utility. In color, smoothness, and symmetrical form, the *kalshi* embodies the aesthetic that crosses the boundaries between media to bring the material culture of Bengal into unity and to bless the world of work with beauty.

The decorative impulse that is subdued in the working pot becomes conspicuous and dominant when the *kalshi* is painted. Hindus paint *kalshis* with scrolling forms borrowed from *alpanas*, designs women draw on the floor for auspicious occasions, and painted *kalshis* are arranged beneath the *murti* to hold holy water during worship. Muslims paint *kalshis* with abstract floral patterns that evoke the promised garden of the Holy Koran, and painted *kalshis* are sold as souvenirs of sacred occasions at the shrines of the Muslim saints. Painted, the *kalshi* declines in utility while increasing in ornament. Then ornament gathers meaning, replacing service to the body with service to the soul in its gesture toward the sacred.

The *murti* completes the reach for the sacred in beauty. It is shaped by the aesthetic. But the purpose of the *murti*, according to Haripada Pal, is instrumental. Haripada has worked hard and traveled widely to make himself the best sculptor in Bangladesh. He makes *murtis* to please God, to achieve release from the cycles of reincarnation, and he makes *murtis* to make money. The executive committee of a temple raises funds from the community to commission a *murti*. Haripada is paid to sculpt images that serve his community, making it possible for others to receive the blessings of God, as he has received the blessing of talent, the source of his art, his livelihood, and his hope. The *murti* works to bring people into connection with power, so their lives on the earth will be better. A bridge between the worlds, the *murti* is, like the *kalshi*, a tool.

The *murti* binds beauty to utility through the sacred. Makers of *murtis* also bring the decorative qualities of the *murti* into dominance when they employ their modeling skills to craft things called toys, small clay statues of birds and animals that are slipped and fired or fired and painted. Utility seems to have disappeared. Yet, the toy sold at the market is useful to the potter — as the painting is useful to the painter — in providing cash. The toy is used by the child in play or by the adult to decorate the home,

Kalshis. Khamarpara, Shimulia, Bangladesh. 1995

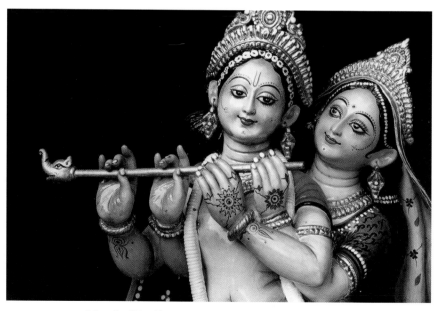

Murti of Radha and Krishna. By Babu Lal Pal.
Khamarpara, Shimulia, Bangladesh. 1996

and playful and decorative things retain a potential for signifi-
cance. The most common toy is a pottery horse on wheels. Pulled
along until it breaks, the horse brings a message, for it is a sym-
bol of the noble, perishable body that carries the soul through
life as the horse bears the rider over the land. And toy horses are
made as votive offerings at the rural shrine of Ghora Pir, one of
the saintly horsemen who brought Islam to the delta of Bengal
in the thirteenth century.

Bright clay toys are things for pleasure, but, like painted
kalshis, they can serve as reminders, helping by religious sugges-
tion to keep people on the right path through life. This little bird
might be no more than an ornament, but it might be the symbol
of the immortal soul that is conventional in Sufi verse. That gaudy
lion might be a simple plaything, or it might be the *vahana*, the
vehicle and symbol of Durga, the goddess in the fullness of power,
the prime deity of Bengal. Patently decorative, toys and painted
kalshis are subtly oriented toward the center of the potter's sys-
tem of creation, where magnificent *murtis* and working *kalshis*
differently apportion the mix of beauty and use.

The *kalshi* and the *murti* are both vessels. One holds water.
The other holds sacred power, symbolized by water. Both are
used, then discarded. Their difference lies in their spheres of op-
eration. The *kalshi* is fired to be useful in daily life. The *murti* is
left unfired to be useful in the sacred moment when people ap-
proach God and ask for worldly blessings. Useful pottery is cen-
tral to life in Bangladesh, helping to shape two great relations. It
connects the creator and the consumer into a society. It connects
people with the deities into the cosmos. Its values are ethical
and religious.

Useful pottery is also art. Among the potters of Bangladesh,
and generally among the world's workers, art is built upon skill.
Developed through training and practice, dedicated in the cre-
ative instant, skill eventuates in forms that vary by tradition and
need. Difficult accomplishments, *kalshis* and *murtis* differently
incarnate the skills of their creators. Testing themselves con-

stantly, potters strive for excellence, shaping natural materials toward beauty. The works of their hands — water jars and statues — witness to their devotion and bear aesthetic value.

Where use meets beauty, where nature transforms into culture and individual and social goals are accomplished, where the human and numinous come into fusion, where objects are richest in value — there is the center of art. That center is touched daily by the hard-working potters of Bangladesh, but it seems to have disintegrated into the haze of the past in the West.

Sweden

For a more familiar story, come west into territory where pottery is decentered, where it no longer meets practical or sacred needs. The pottery at Raus in Skåne was founded in 1911 by Ludwig Johnsson. With the death of the founder, Hugo Anderberg became master of the works in 1947. As the need for salt-glazed stoneware declined among the farming people of southern Sweden, Hugo decided to let the pottery die, rather than pass it into incompetent hands.

Then he met Lars Andersson, a city boy who had taken classes in pottery and worked as a teacher of ceramics. Hugo became to Lars as a grandfather, teaching him all the tricks of the big kiln before he was killed in a motorcycle accident. Lars has installed a museum in the pottery where old objects validate his practice for the visitor. Surrounded by models from the past, Lars has narrowed his action to the replication of traditional forms. His handsome brown jugs and crocks are sturdily utilitarian in appearance, but no one puts them to work. They are amazingly exact sculptural representations of useful pottery.

At Raus, in a big brick building, using Hugo's old wheel and Hugo's huge kiln, Lars Andersson finds satisfaction in his work. Then cleaving to old techniques and forms, he answers the responsibility of tradition, connecting himself through new works

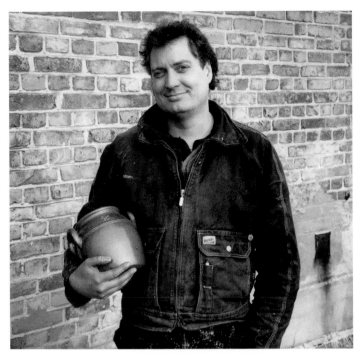

Lars Andersson. Raus, Skåne, Sweden. 1993

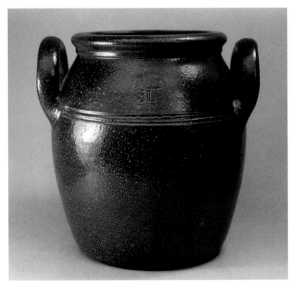

Crock. By Lars Andersson. 1993

to his revered teacher, Hugo Anderberg, and to the wider history of his place. His customers do not need crocks to store milk. They need to avoid anomie and gain connection, reaching through the things of their region to their history, joining Lars in the spatial — Scanian and Swedish — identity that his pots embody.

As for value: the salt-glazed crocks of Raus fulfill Lars Andersson's artistic desires, and his customers find them to be, like other works of art in the late West, objects that are decorative and historically evocative.

Georgia

A similar story, set nearer home, can be told about Mossy Creek in Georgia. The pottery founded there by John Milton Meaders in 1892 was revitalized in the 1930s, when, at a low point of local need, outsiders discovered John Milton's youngest son, Cheever Meaders, still at work in the old way, digging the clay, throwing it on a treadle wheel and firing it in a wood-burning tunnel kiln, making ash-glazed utilitarian ware. In 1967, the year of his death, Cheever burned his last kiln for the Smithsonian Institution, and his son Lanier, recognizing the new market provided by collectors of folk art, left his bad job in a mobile home factory and took to pottery full time.

In the early 1970s, it seemed that Lanier would be the last in the line, but when he fired his final kiln in 1991, others were at work. Lanier's younger brothers, Reggie and Edwin, had returned to the trade. His cousin C.J. retired, came home to north Georgia, and refined the ash glaze that ornaments the family's ware. With his wife, Billie, C.J. made a hundred commemorative pots to celebrate a century of continuity for the Meaders family's trade in 1992. His son, Clete, followed his father into the clay, and when the Olympic games of 1996 were held in Atlanta, Clete advertised his family's ware to be the official folk pottery of the Olympics. Meanwhile, Lanier's nephew David, a truck driver, built an old-time kiln in his yard to fire the pots thrown by his

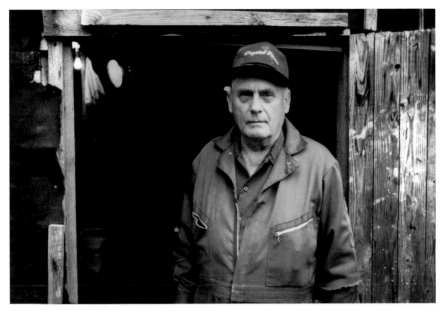

Lanier Meaders. Mossy Creek, Georgia. 1991

Pitcher.
By Lanier Meaders.
1967

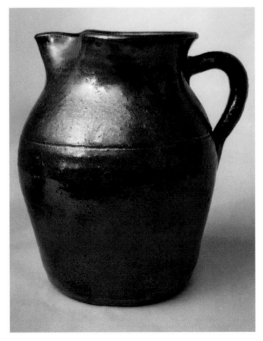

Face Jug.
By Lanier Meaders.
Mossy Creek, Georgia.
1967

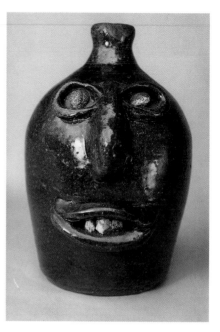

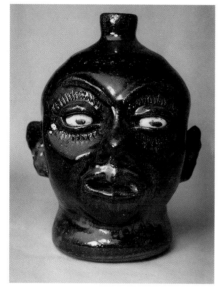

Face Jug.
By Lanier Meaders.
1975

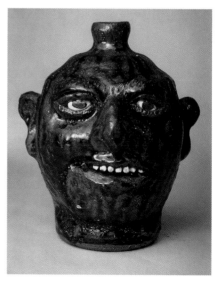

Face Jug.
By Lanier Meaders.
1991

wife, Anita, and then they moved their operation to the old family site, using Lanier's shop and kiln, and asserting a claim to a central role in the family's tradition.

C.J. Meaders is not bothered that his customers do not buy his pots to use, but because, in his words, they want to own "a piece of history." Like Lars Andersson, C.J. holds firmly to old forms and technology, and he works to make each pot better than the last. His churns stand tall beneath their skins of streaky green glaze. They could be used.

Needing money, just as you do, potters work to the market. In the past, their customers wanted many churns and crocks and jugs, and the potters for sport made a few comical pots, at once jugs and grotesque human heads. Collectors might term them face vessels, but the potters call them ugly jugs, and "face jug" is the usual compromise. From their customers, the potters have learned a history of the form, and they repeat it during commercial exchange. The story is that the face jug was developed by slaves who worked as potters in South Carolina. Then the idea was carried up to the highlands and assimilated into the Appalachian cultural mix. It used to be acceptable to write of the Anglo-Saxon purity of the mountain people, but Lanier Meaders spoke proudly of his Native American ancestry, and the face jug seems to be, like the banjo, an Appalachian trait with an African-American origin. The potters, at least, find the idea reasonable.

Now quantities have reversed. Conditioned by ideas from art-appreciation classes so suffused with the idea of the pictorial that the craft of photography has been embraced as an art, and the art of pottery is still called a craft, today's buyers want few churns and many face jugs. Learning the taste of his customers, Lanier Meaders began to fill the kiln with face jugs, and those jugs in time moved steadily from haunting abstraction toward realism and humor. Once rare and known to only a few potters — notably Burlon Craig and the Browns in North Carolina, the Meaders and Hewell families in Georgia — the face jug has become the common product of the Southern potter.

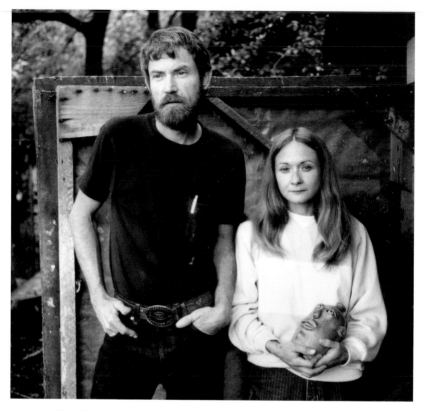

David and Anita Meaders. Mossy Creek, Georgia. 1991

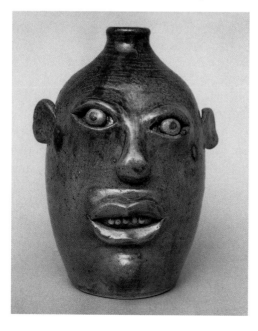

Face jug.
By Anita Meaders.
1991

David Meaders says he prefers the pure forms and rippling glazes of the utilitarian ware made by his grandfather Cheever, but what they want now is face jugs. The jugs made by David's father, Reggie, did not follow Lanier's into realism, and David's wife, Anita, has recaptured some of the old strangeness in her face jugs, which are, in my opinion, the best of the new lot. A quiet, delicate woman, Anita handles hard work and a hard life with stoic elegance. She has found a source of pleasure and handy cash in the familial tradition that Cheever and Lanier nurtured through a shaky passage.

Lanier Meaders died in 1998. On the wall at the home of his charming widow, Betty Jean, framed letters from two presidents of the United States flank the certificate Lanier was awarded as a national heritage fellow. Jugs he made fetch thousands of dollars at shows of antiques, and he is affectionately credited with establishing a new market among collectors for the family's ware. The wheels keep spinning, but it is not easy. At the age of seventy-eight, Edwin remains at work in his tiny shop, assembling turned components and modeling them into the perky roosters that he makes, four a week, to bring him his money. C.J. Meaders suffered a stroke, but his family and friends fired the kiln he had filled, and he was back at the wheel in the summer of 1999. Lanier had hoped to insure continuity by letting his nephew work in his father's old shop. But David found it hard to calm into the potter's steady life, and though Anita continues, as the potters say, to make, she works at home. The old shop is empty.

The center of north Georgia's tradition has shifted south to Gillsville, where the man in command is Chester Hewell. As he is for the potters of Mossy Creek, Lanier Meaders is a hero to Chester Hewell; he was the one who kept it going, passed it on. When Chester began to make face jugs, in the middle of the 1970s, he worked with Lanier, learning his style, and Lanier fired Chester's first face jugs. At the end of his life, Lanier could no longer manage the kiln alone, and Chester fired Lanier's last little pieces.

41

The members of the Meaders family work in isolation, producing pots in small numbers for collectors. The market is uncertain, the return is modest. But Chester Hewell, a brilliant entrepreneur, has built a massive operation, parallel in pattern to the great ateliers of Asia. In a vast factory, using the latest equipment, Chester Hewell manufactures unglazed pottery for the garden, buff planters that he ships for sale throughout the United States. His garden ware provides the base for a robust economy, and Chester has diversified, buying land on which cattle graze, adding a factory for berry baskets. Within that system, on a firm financial foundation, Chester has shaped a secure home for art, building a small shop and brick tunnel kiln where local clay is turned and burned in the old-time way.

The Hewells have been making pottery in Gillsville for as long as the Meaders family has been at Mossy Creek. Though he learned about face jugs from Lanier Meaders, it was a fair exchange, for Chester believes that one of his ancestors introduced the idea of the face jug to northern Georgia. Today, three generations form a cooperative unit in Gillsville. Chester shares the daily labor with his youthful parents, Harold and Grace Nell, and with his sons, Matthew and Nathaniel. All of them work at the wheel, throwing planters and strawberry jars, pitchers and jugs. All of them have their own, distinctive versions of the face jug.

At twenty-seven, Chester's son Matthew has become the tradition's new force. Centering and raising the earth of Georgia, Matthew repeats the motions built into his body in boyhood. His bones and muscles settle into smooth old grooves while damp clay rises in his hands. His prime pleasure, the first aesthetic dimension of the potter's art, lies in the act of making. It feels good to do what you know how to do. Again and again he accepts the challenge of a difficult task. The mind and body run together, and he is rewarded with the gentle joy of completion. Matthew can make something out of nothing much. Standing tall on the wheelhead, the jug tells him of his success.

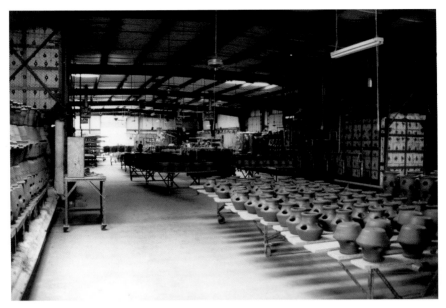

Hewell's Pottery. Gillsville, Georgia. 1991

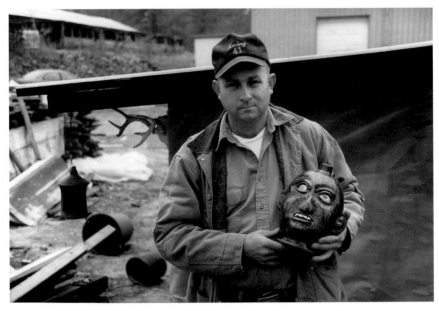

Chester Hewell. Gillsville, Georgia. 1994

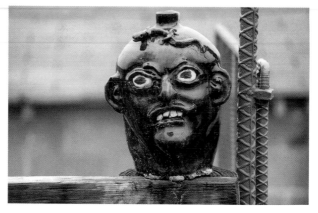

Face jug.
By Chester Hewell.
1994

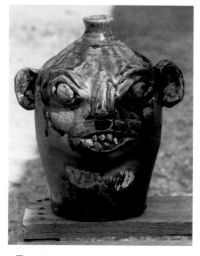

Face jug.
By Chester Hewell.
1975

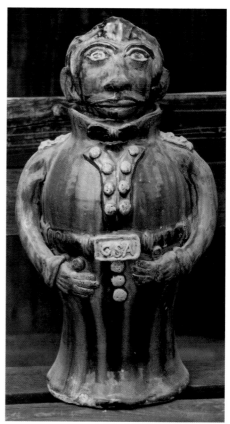

Rebel.
By Chester Hewell.
Gillsville, Georgia. 1990

Time is passed in concentration and stopped in the pot that repeats his biography. When Matthew was a child, he made small things. Now the giants that lift in his hands tell the tale of his growth. They bespeak an individual, a man who has matured to mastery. And they reach back in time, gathering the family line that runs from old Nathaniel, who was born in 1832, through E.D. and Bud, through Harold and Chester to Matthew himself, and now seeks its future. Matthew says that his son, the baby in his arms, will be a potter. He named him Eli Davenport after the first of the Hewells in Gillsville, and he is saving for him a treasure from the past, an old jug stamped "E.D. Hewell, Gillsville, Ga."

Matthew Hewell's work is personal, familial, and it is self-consciously regional. His masterpiece is a towering, tapering jug in a form he associates with Barrow County, farther south in his state, and he crafts, in addition, allusions to the whole of the South.

With pride, Chester Hewell wears a brass belt buckle cast with the letters CSA, and he makes mugs like the ones that were used by the Confederate army. In the 1980s, Chester saw a rare old work from Jugtown in Georgia. More than a face on a jug, it was a pot topped with a cannonball of a head. The arm that once lifted a pipe to the lips had been broken off, and because, he said, he wanted to see what it looked like, Chester made a new one. Then he made another man, this time an officer in the Confederate army. If it depicted anyone, Matthew said, it would be Old Pete Longstreet, the Georgian who ranked highest in the Southern army, but it is not a portrait. It is a generalized ancestor, a rebel, a symbol. Matthew has repeated his father's innovation and added one of his own, a Confederate woman. Her old-fashioned dress matches the shapes raised on the wheel. She waits at home for her man at war.

Matthew Hewell's identity as a man, a potter, as a son and father, the inheritor of a family tradition, as a Southerner — all that comes to oneness in his determination to live a life that is rooted deeply and dedicated to simplicity. Like the Mennonites

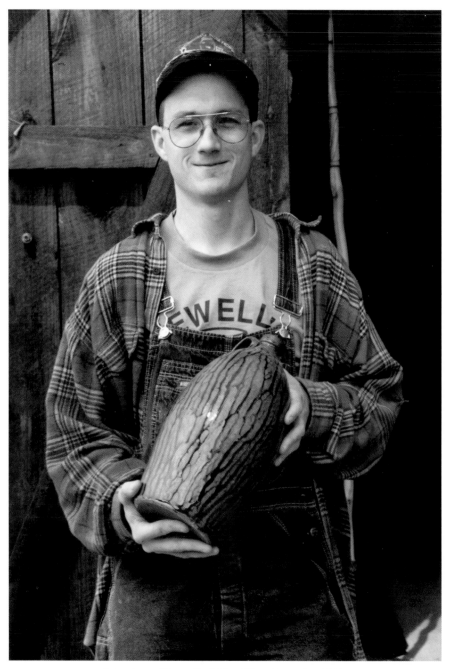

Matthew Hewell. Gillsville, Georgia. 1999

and Amish he admires, he chooses to stand apart, to rebel against the modern. He is a country potter, wants no other life, and as the millennium ends in technological extravagance, in excesses of ego and greed, Matthew elects to work with his hands, shaping the earth of his place into the pots of his place. He chooses to grip to the old, interdependent values of work, family, and faith.

And faith. When Matthew signs his name on the bottom of his pots, he often inscribes as well a reference to John, the third chapter and sixteenth verse: For God so loved the world, that he gave his only begotten Son, that whosoever believeth in him, should not perish, but have everlasting life.

Here is a jug, stoneware, ash-glazed. The more we know, the more precisely we can locate it, attributing it to America, the South, Georgia, Gillsville, the Hewells, and at last to young Matthew. The values in the pot are the values in the man. It is upright, direct, old-timey. In its austerity it carries, like soft overalls or a white country church, the plain style of the highland South. Like Matthew, the pot is committed to work and place and tradition. Like him, it is not grim. It displays utility in its form and delight in the play of the glaze that melted, broke, and ran, coating the form with ornament. At once useful and beautiful, the jug is shoved toward the decorative when it is modeled with a crazy face, bug-eyed and toothy. While the potter explores a taste for the ugly and asks for a laugh, the pot takes on history, remembering the mixed, vexed story of the South.

The potters of northern Georgia make signs of the self and declarations of their position in the world. They sell bits of decor that are culturally resonant, face jugs that suggest African-American origins and symbolize the folkways of the Southern uplands. Their deracinated customers buy craft, history, and connection to the land.

The new pot from Georgia is, like the new Native American pot, a high-class souvenir, tending through ornament to art, tending through reference to cultural symbol. Set in its own place, the work's values deepen.

Acoma

Wanda Aragon is a master of the ceramic tradition of Acoma, a village more than a thousand years old, built atop a mesa in the dry wideness of New Mexico. To locate the values that elevate things into art, we are inclined to focus on objects, contemplating products. Wanda concentrates on process, finding the qualities that define art first in technology. Her art accepts and perfects the gifts of her land. Clay is mined out with a prayer. Rock hard, it is ground down on a stone and dampened with water, which is as rare and precious in New Mexico as it is abundant and terrible in Bangladesh. Wanda's sister Lilly Salvador, whose work has been purchased by museums of fine art in Boston and Cincinnati, says that when they make their pottery, their minds are filled with prayers for dampness. Cusped and whirling clouds flow and break over curved surfaces. Slanted lines are driving rain. Spots are snow. "All our designs," says Wanda Aragon, "are a prayer for rain."

Driving their cattle in the mountains, Wanda and her husband, Marvis, stay on the lookout for rocks that might be powdered into paint to decorate their pottery. They search, too, for shards, for bits of ancient pottery that are ground to dust and mixed in the clay for temper. That dust becomes the blood of the clay body — the pot will contain the pots of the ancestors, whose pots contained the pots of their ancestors. Old blood revives with dampness, and a squeeze of pliable clay becomes the seed of a fresh form. The new pot is shaped in the bottom of a broken old bowl, borrowing its shape, and then, damp and vulnerable, it is lifted out tenderly and allowed to stand on its own. The base is ready to receive the coils through which it will grow, widening and rising into a new being. Slipped, then painted with earthy color in fine and dense designs, the new pot is clothed and prepared for the trial by fire.

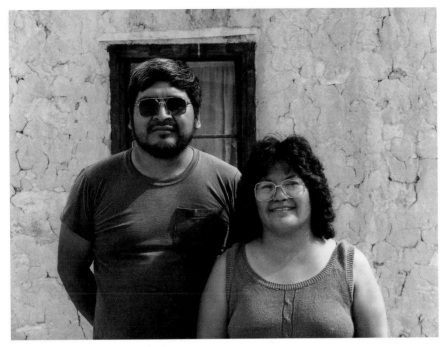

Marvis and Wanda Aragon. Acoma. 1987

Lilly Salvador. Acoma, New Mexico. 1988

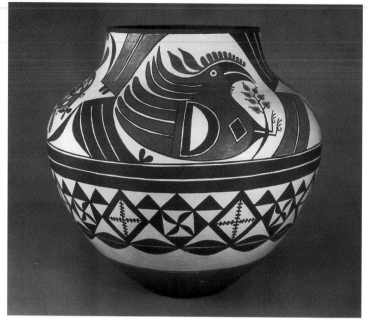

Jar. By Lilly Salvador. Acoma. 1997

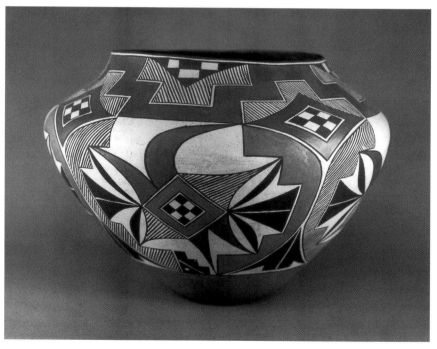

Jar. By Wanda Aragon. Acoma. 1987

Not long ago, the potters at Acoma would not call a pot traditional unless it had been fired outdoors, exposed to risk beneath the sky. But so much work goes into creation, into raising and scraping and decorating the fine walls, and so much at home depends on sale, that electric kilns have slowly come into acceptance. But there is no compromise in materials. Traditional pottery is made of the earth and shaped by hand. Things molded out of purchased clay and painted with synthetic colors are called ceramics. At Acoma, the difference between the two — between "traditional" pottery and "ceramics" — is the difference between art and other things.

Wanda Aragon's splendid water jar rises out of her arid place. Local and adamantly natural substances are processed in the old way, the laborious way, into signs of the conscientious self. Wanda's pot contains her skill and will and taste. Next, it contains the teaching of her mother, the great master Frances Torivio, who turned ninety-three when I was writing this paragraph in April of 1998.

As in Georgia, the pottery of the American Indian communities of New Mexico and Arizona can be read as emblematic of a broad region, but its strength depends on talented individuals working in family lineages. The most famous potter at Acoma was Lucy Lewis, who developed new ideas for decoration through study of old potsherds. She died in 1992, but the daughters she taught, Emma Lewis Mitchell and Dolores Lewis Garcia, continue her fine line, and her burly son, Drew, is one of the men who have recently turned successfully to pottery.

In the period between 1930 and 1960, when the idea of the modern was still fresh with promise and the world was distracted by war, the traditional arts hit their low point in history. At Acoma, in those days, when the ceramic tradition could have descended through shortcuts into cheap souvenirs for tourists, Lucy Lewis was one of those who held to the old, high standards. Frances Torivio was another. Frances taught her daughters, Ruth, Lilly, and Wanda. Then Lilly and Wanda taught their daughters. With Wanda's encouragement, her husband, Marvis, took up the

art, and he told me that, while pottery is now a woman's craft, in his grandfather's days, before men were forced to accept paid employment away from home, they made ceremonial vessels in the kiva. Now Wanda's daughter-in-law, Delores J. Aragon, has emerged as a leader in the new generation of potters.

Wanda Aragon follows her mother as an artist and a teacher. While responding to her mother's models, and repeating the geometric designs that belong to her family, Wanda also reaches farther back, self-consciously effecting revival through the study of Acoma's old works that have been preserved in museum collections. Searching through storerooms and leafing through books, Wanda has decided that the finest works of her tradition were made in the 1880s. Their bold geometry suits her personal style. The fit of their ornament to their three-dimensional forms would excite any designer. And Wanda has brought their spirit to new life in wonders of technical mastery.

Her works in clay write Wanda Aragon's signature on the world. They entail her environment, remember her teacher, and revive her tradition at the greatest moment it knew before the present. Outstripping the past in precision of execution, Wanda's creations display the sure touch of her hand and her great gift as a designer. An artist, she enters the market with confidence, and in the hectic commercial scene, she is triumphant, victorious because she has won a plenitude of awards in competitions, because she earns enough money to be able to do her art, and because her success has not required her to abandon her standards, the contract to excellence she has made between herself and her tradition.

At the Native American arts fairs where Wanda Aragon sells her work, the exhibitors array their creations on tables before them, and answer the same questions again with unbelievable grace and patience. Trying to gauge the worth of the things they lift for inspection, Anglo buyers ask how long they took to make and what they mean. The answers emphasize the tedious labor involved and the historical and sacred significance of the objects, investing commodities with cultural meanings and smoothing the transaction that

brings the artists money, and, as Wanda stresses, that might bring them new friends. At the same time, she tells me, the artists enjoy visiting with each other, trading goods and ideas. The market is a locus for friendship and information, as well as commerce.

At such a fair, Wanda's mother, Frances Torivio, learned a new form from another Native American potter who told her the tourists loved them, and she became the first at Acoma to model the storyteller. The form had its origin at Cochiti pueblo. Though the Cochiti tradition, like that of Acoma, has always been dominated by useful vessels, a figurative strain was added in the late nineteenth century. Potters at Cochiti made caricatures of outsiders and images of mothers singing to children. When Helen Cordero of Cochiti found her talent in midlife, she turned from pottery to shaping figures of clay. One of the first times she exhibited her work, Alexander Girard, a designer and manic collector of folk art, bought everything she had made and commissioned a larger singing mother with a greater number of children. Helen Cordero thought of her grandfather, a famed storyteller and anthropological informant, and she shaped a statue of him telling a tale to his five grandchildren. Since she was one of those children, it was a contextual self portrait, and since her grandfather was one who talked to outsiders, telling them about his culture, her sculpture fit the dynamic of cultural exchange that accompanies the commercial exchange in the market. Her figure was the first storyteller.

That was 1964. Since that time, more than three hundred potters in thirteen pueblos have made storytellers. It has become, Alexander Girard told me, "a regular storyteller industry." Helen Cordero died in 1994, but her storyteller has risen into a regional symbol. Visitors to the Southwest purchase Indians made by Indians out of the earth.

When Frances Torivio became the first at Acoma to make a storyteller, she was attracted by more than commercial potential. The idea suited her expressive style and her wonderful sense of humor, and her little storytellers are distinct in the crowd. Ethel

Shields, a potter at Acoma, has pursued the possibilities of the comic by creating storytellers of beasts and tourists. The grinning bear who sits in for the grandfather comments ironically on the tourist's perception of the Indian as somehow natural and wild. The tourist modeled in clay, a camera slung around his neck, bounces stereotypes back. Buying souvenirs, visitors take home images of themselves. During exchange, misunderstanding is wittily acknowledged and graciously submerged in good humor. Ethel Shields finds her work fun.

In a different mood, Frances Torivio's daughters Wanda Aragon and Lilly Salvador shape their storytellers with painstaking attention to craft, Wanda's embodying her desire for clean design, Lilly's revealing her interest in narrative detail. To every show, Lilly brings a pretty storyteller, and positioning it among her creations, she asks it to assist her in the difficult business of selling. It is with them as it is with the Bengali sculptors who make toys between commissions for *murtis*. The money Wanda and Lilly gain through the sale of little statues enables them to keep to their main work, praying for rain while shaping clay into water jars that are dressed with geometric designs to present their tradition in its best modern moment.

The fine pottery of Acoma describes relations among habitat, heritage, and the talented self, and it tells of our times. The pots of Acoma, like those of northern Georgia, exhibit at once accommodation and resistance. Accommodating themselves to the desires of their patrons, the potters of Acoma make images, statuettes of adults telling tales to children that have, like the face jugs of Georgia, antecedents in history, but which, like the face jugs, have become common in response to the market's demands for figurative art.

At the same time, like traditional artists throughout the world, they have stepped out of the rush for modernity and returned reverently to ideas from the past. Acting in a spirit of revitalization, they resist the technological progress that divides people from the earth and separates the mind from the hands, reducing

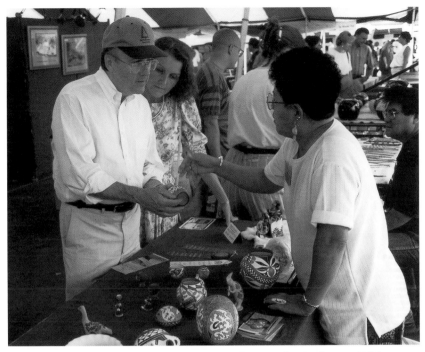

Lilly Salvador. Indian Market. Indianapolis, Indiana. 1996

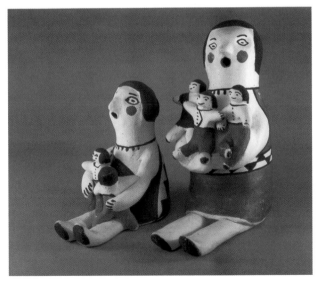

Storytellers. By Frances Torivio. Acoma. 1988

art to design. In a time dominated by industrial production, potters at Acoma and in Georgia have determined to hold to elder techniques, digging their own clay and forming it in their own hands, while their nimble minds direct the process of creation. This mix of accommodation and resistance establishes a frame of adaptive revival within which forms and techniques hold steady but functions shift.

Once, the pot of Acoma, like that of Bangladesh, was for carrying water. It is still used in ceremonial circumstances, during worship, but no one today would carry the workaday water in a jar worth a thousand dollars in a gallery in Santa Fe. The use now is ornamental for both the potter and her patron, but the functional shift is the graceful consequence of the manifold reality of art. When it was made to use, the water jar of Acoma was also, like the *kalshi* of Bengal, decorative in form, proportion, and detail, so its relocation in a decorative setting requires no radical alteration of technique or form, though it inspires greater precision in ornamentation. Enhancing and refining ornament, artists challenge themselves and invest their works with a quality that excites the eye and attracts the attention of buyers who understand the art incompletely. In the new age, the potters of Acoma and Georgia do not surrender their tradition. They drive it toward new perfection.

Turkey

If the functional shift from utilitarian to ornamental seems modern, or even, perhaps, postmodern, come to a place where pottery has been decorative for half a millennium. Fine ceramics have been made continuously since the late fifteenth century in Kütahya, a lovely city in the mountains of western Turkey.

When I arrived in Kütahya in 1985, the masters told me there were twenty-three ateliers in the city. In 1997, I was told that no one knew the number, maybe it was two hundred. A year later

the estimate had risen by fifty. Most of the shops are tiny operations: a man or woman working alone beneath a bulb in the kitchen, decorating plates purchased from a large atelier, and then signing them with the name of a firm that might last for only a few months. But the masters tell me that thirty of the workshops are solid and the market for their ware is strong. Turks have money and love to shop, tourists are coming in steadily increasing numbers, and the potters have participated in Turkey's rapid rise to prosperity. A third of the city's population is involved in the production and sale of ware that is painted underglaze on a composite white body.

The chief products are two. They make tiles to revet the walls of the concrete mosques being built throughout the nation as signs of faith and local pride. They make plates, domestic in scale and form, that are hung on the wall to do in the home what tiles do in the mosque, bringing brightness through their materials and meaning through their decoration.

Tile or plate, flower vase or water jar, the ware is called *çini*. The word is cognate with "china." It designates a ceramic type, like "stoneware" or "porcelain." The ware was developed in response to the stunning wonder of Chinese porcelain. But *çini* is compositionally unlike porcelain. It can be fired at a lower temperature so that the rich color can be applied under the glaze, rather than enameled over the glaze in the East Asian manner, which requires sequential firings, risking loss in the kiln.

The word *çini* also names the firms that produce the ware. Süsler Çini, an atelier of the middle size, was founded in 1950 by Ali Özker. (I like these dates and names, for they remind us that traditional pottery is not the spawn of superorganic forces, but the creation of real individuals at work in time.) When I showed up in Kütahya, İhsan Erdeyer, the master at Süsler, welcomed me into understanding of his craft. In a city that its workers call the city of jealousy as well as the city of *çini*, where some of the masters protect generally known facts as though they were deep secrets, İhsan is famed for his generosity. I watched the work

while İhsan explained how six natural materials — kaolin, sand, chalk for whiteness, quartz for brightness, and two clays for plasticity — were mixed, milled, dampened, and strained through silk to make the refined white substance (they call it mud) that was thrown on the wheel for hollow ware, jiggered on the wheel for plates, and patted into molds for tiles.

Süsler Çini was a rambling half-timbered building enclosing a courtyard. In the dusty dark, İhsan Erdeyer managed a team of workers who jumped at his every quiet word. İhsan directed the shaping of forms, then he recentered them on the wheel and shaved them to clarity before slipping them with a whiter, brighter coating of clay. Fired, then painted in two stages by young women and men, the ware was glazed by the master in a fritted lead solution, and then fired again.

At the old Süsler, the master stacked the ware into delicate, dangerous columns within a domed and cylindrical kiln, sunken in the floor. Then one of İhsan's workers went down and shoved dry pine into the firing chamber, while the heat rose slowly and held steady at a point above eight hundred and sixty and below nine hundred degrees centigrade. They judged the fire solely by eye, peeping through glassed spy holes, maintaining the heat at the perfect pitch for ten or twelve hours, and then letting the kiln cool slowly. If the heat is too low, the glaze will not convert, the ware will not shine. If the heat get too high, the colors run, smudging the design. If the kiln cools too quickly, the glaze will crackle and craze. In some traditions — the Raku of Japan providing a fine instance — the masters invite accidental effects in firing, but not in Kütahya. The wish is for total control over natural forces — earth and air, water and fire — a control that is materialized in a pure white body and sharply defined forms, spread with a sheet of transparent glaze.

The aesthetic has not changed, but the work has gotten easier. In an effort to banish smoke from the sky, the municipal government has decreed electric kilns to be obligatory in new workshops. The temperature in the electric kiln is easier to regulate,

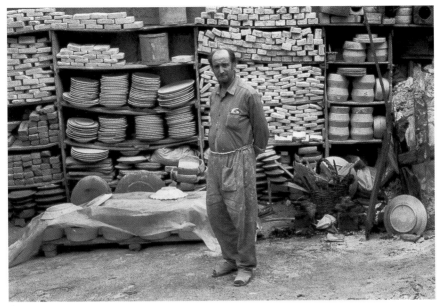

İhsan Erdeyer. Süsler Çini. Kütahya, Turkey. 1987

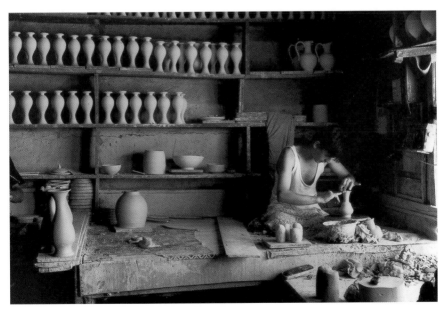

Mustafa Oruç. Nakış Çini. Kütahya. 1994

and the hard labor of stoking the kiln has ended. Some old masters decry a decline in quality; they miss a depth in brilliance that came from wood-firing, but they have to be pleased by a decrease in the number of pieces lost in each kiln. When Süsler Çini was torn down in 1991, making way for a high-rise apartment building, İhsan Erdeyer moved his operation into his old home, rebuilding it into a workshop, where two electric kilns stand on the ground floor, and the decorators work upstairs. The shop's effort coalesces in pieces of *çini* that appear to the eye like gemstones set on snow beneath a clean mountain stream.

Overseeing his squad, the master works to assure the material richness upon which the beauty of *çini* is based. Should you ask whether the ware is art or not, the potters in Kütahya, like those in Acoma, would exemplify the rule that quality must be distinguished within kind. They would tell you that some is art, some is not. Most *çini* is only "factory work," the city's stock in trade, the basis of its economy, but some is "special work," unquestionably art — the Turkish word is *sanat*.

Art in Kütahya depends upon a small number of great masters who both design and paint the ware, and who are obliged to teach as well as create. The greatest was Ahmet Şahin, the twentieth century's grand master of Islamic ceramics.

Ahmet Şahin became a hero to his city in 1927, when he was only twenty. At the beginning of the twentieth century, half of Kütahya's workers were Armenians. They left to repair the tiles on the Dome of the Rock, never to return, and today their descendants make a variety of Kütahya *çini* in Jerusalem. During the Turkish War of Independence, in the violent aftermath of the First World War, Mehmet Emin, the city's leading master, was killed. The Armenians were gone, the old master was dead, and in the early days of the Turkish Republic, Kütahya's tradition seemed at an end. Then Ahmet Şahin formed a partnership with Hakkı Çinicioğlu, Mehmet Emin's son, and they made a few gigantic, intricately painted vases that inspired the city and brought the workers back to work. Since that time, while quality has waxed and waned,

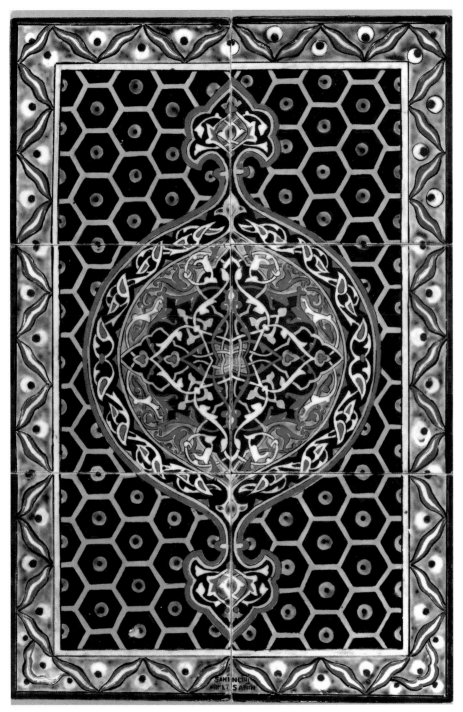

Tile panel. By Ahmet Şahin. Kütahya, Turkey. 1989

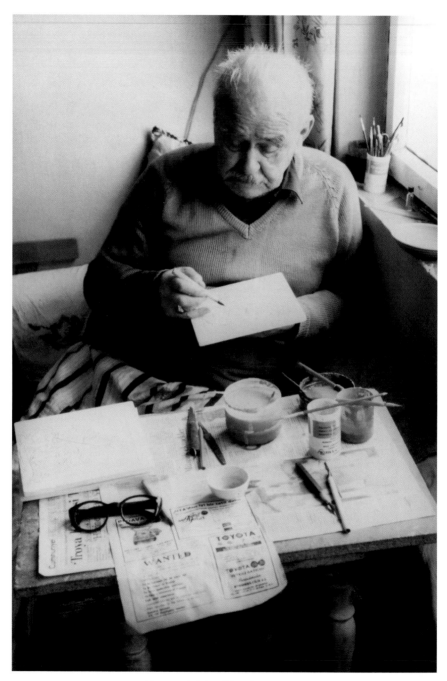

Ahmet Şahin. Kütahya. 1991

the *çini* industry has provided steady employment to Kütahya's people. In 1927, there were two young men in the trade. Now it supplies the income for something like forty-five thousand people.

The partners parted. Hakkı Çinicioğlu established a firm to produce the city's normal ware. Ahmet Şahin, they say today, was *tek adam* — the one man in the past who was dedicated to quality. He became Kütahya's great designer, drawing patterns on paper that were pricked into stencils in the workshops to pounce designs onto the slipped, biscuit surface for painting. Drawn in black, filled with color, Ahmet Şahin's designs were transferred to seventy percent of Kütahya's tiles and plates, and his taste diffused through commerce to become general in Turkey. He designed for the ateliers, and he painted his own designs with manly firmness to challenge the city as a whole, to keep the standards high.

His art, Ahmet Şahin told me, is the greatest of all. The painter buys paint and brushes, paints his picture, and he is done. Easy. But Ahmet Şahin ground his own paint. He made his own brushes out of the bone from a goose's wing and the hair from a donkey's mane. He painted his picture, and then submitted it to the judgment of the flame. Standing back while God decided, Ahmet Şahin waited anxiously for the kiln to be opened. He was downcast by every failure and exhilarated by every blessed success. *Çini*, he said, is a rose picked from the fire.

Ahmet Şahin wanted no other work, and when he was working, he said, he never knew fatigue or melancholy. At eighty-four, he still sat by the window of his home on the hillside, painting beautifully, and he told me to tell them to put a brush, some paint, and a few raw pieces in his coffin, so he could keep working on his journey to the other land. When I came in 1993, he wrapped me in a hug and emitted an old man's wail. His eyesight was gone. He could not work. The Ahmet Şahin who was his nation's greatest master had vanished. I was able to arrange a belated award for him from the Turkish government, but the days that remained were filled only with waiting.

He told me he was satisfied, for he had left his art in good hands. When Ahmet Şahin died at the end of 1996, a new generation had risen around him. His son Faruk, scholar and artist, brought a fresh delicacy to Kütahya's painting. Along with Hakkı Ermumcu, who worked in quiet isolation, Faruk excited the city's new masters, İbrahim Erdeyer and Mehmet Gürsoy, inspiring them to take responsibility for the art his father protected in its moment of peril. Ahmet Şahin's son Zafer, though drawn to the abstract art of modern Europe, trained his son, Ahmet Hürriyet, and Ahmet's wife, Nurten, in his father's ceramic tradition.

At first, Ahmet and Nurten worked in their apartment. Then in 1989, a businessman set them up as the managers of a new atelier, Işıl Çini, where they used Ahmet Şahin's old designs and led a team of young workers in the production of factory ware of the highest quality. Soon their partner in business double-crossed them, leaving them with a huge debt that they worked off slowly. Nurten would get her son off to school, and then, smoking too much, she would lose herself in delicious creative concentration. Next to her husband and son, she said, she loved her work the most. After the publication of my book on Turkish art with Nurten's portrait on the cover, a big businessman in Istanbul, fantasizing a global market for *çini*, opened a massive modern workshop in Kütahya, Doğuş Çini, in 1996. Ahmet was named master of the works. Nurten was charged to teach her style to a studio full of young women and men. The businessman could only think of their creations as commodities, as so many potatoes or radios to sell. He pressed them to expand production and slight the art, but there is no room in Nurten for compromise on standards. When profits rose too slowly, he abruptly dissolved their partnership in the summer of 1998. Betrayed again by their capitalist, Ahmet and Nurten returned to their apartment with debts to pay and plates to paint. Despite it all, in times of hope and heartbreak, Nurten Şahin has kept her head, and her work has steadily improved, coming closer and closer to that sweet spot in design where complexity and clarity meet.

Nurten and Ahmet Hürriyet Şahin in America. 1994

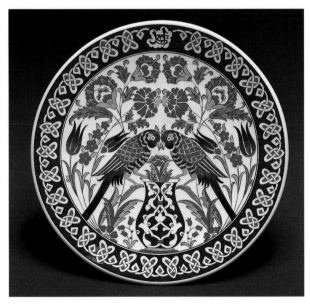

Plate. By Nurten Şahin. Kütahya. 1998

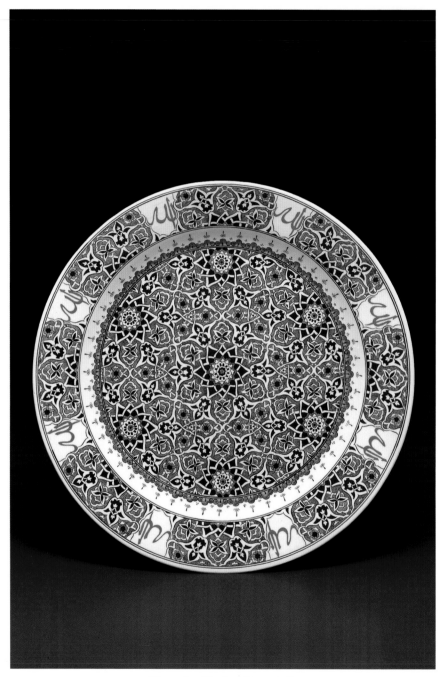

Plate. By Kerim Keçecigil.
Kütahya, Turkey. 1994

The view from the citadel.
Old Kütahya. 1993

İbrahim Erdeyer with his wife, Ayşe, and their daughters,
Gizem and Gözde. Kütahya, Turkey. 1997

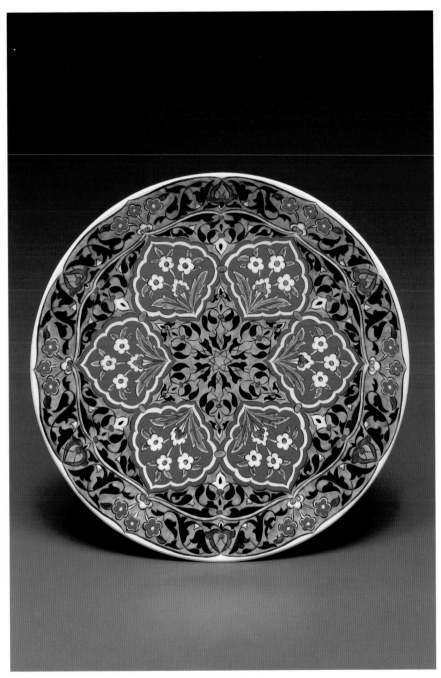

Plate. By İbrahim Erdeyer.
Kütahya, Turkey. 1994

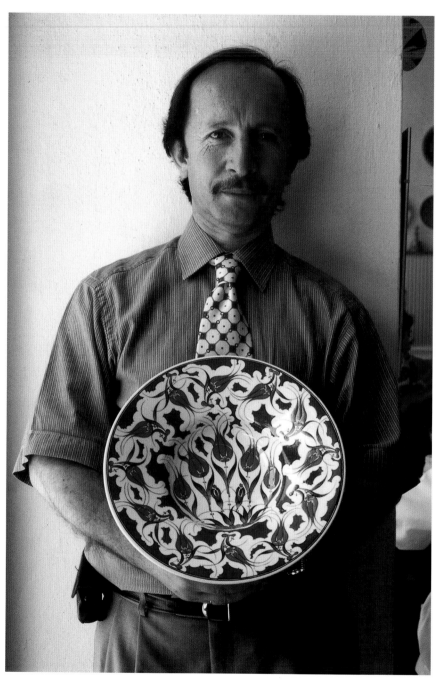

Mehmet Gürsoy with a new plate from his atelier.
Kütahya, Turkey. 1997

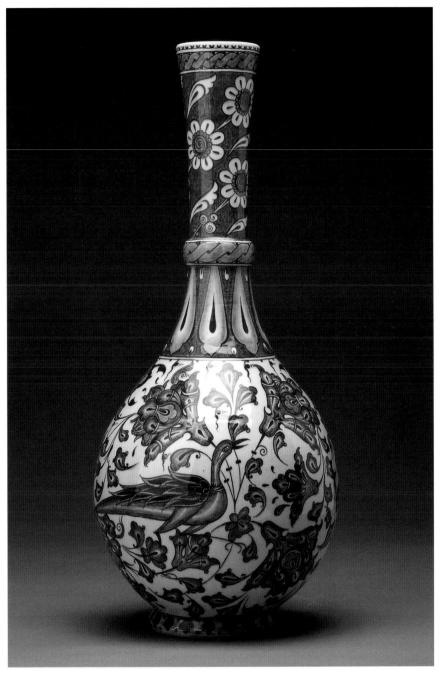

Sürahi. By Mehmet Gürsoy.
Kütahya, Turkey. 1990

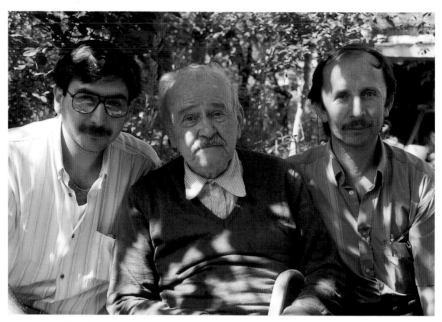

İbrahim Erdeyer, Ahmet Şahin, Mehmet Gürsoy. 1993

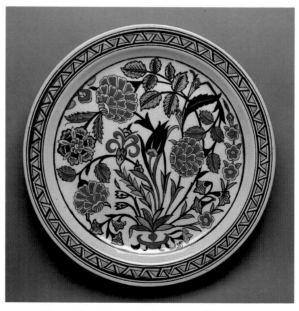

Plate. By Ahmet Şahin. Kütahya. 1985

In the study of a traditional art like pottery, it is no fitful struggle to bring both women and men into the story, and it has gotten easier, for a softening of gendered distinctions is one aspect of contemporary art. Men are now potters at Acoma. Women have long worked as decorators in Kütahya, but now they are gaining names. Nurten Şahin is first. It is hard, she says, to be an artist in the modern world, impossible to be a female artist, but she is one of three who lead the city's art today, who brought satisfaction to Ahmet Şahin at the end of his life. The others are İbrahim Erdeyer and Mehmet Gürsoy.

When I met İbrahim and Mehmet in 1985, they were painting plates in the Süsler Çini outlet on Kütahya's main street. Since then, both of them have gone from success to success, artistically and financially. In 1997, we zipped around Kütahya in İbrahim's new van and Mehmet's white Mercedes.

İbrahim Erdeyer was raised in the potteries. He mixed the mud in boyhood and fired the kiln as a teenager, learning the whole trade from his father, İhsan, the master of Süsler Çini. Understanding his desire and recognizing his skills, İhsan freed İbrahim to paint and put him in charge of commerce. A man of great charm, in whom, Nurten Şahin says, there is no badness at all, İbrahim surrenders his summers to the hard job of selling, traveling the road and expanding the business. In the quiet of winter, when the soft snow falls, he wields the brush with consummate artistry.

In 1987, Mehmet Gürsoy formed a new partnership called İznik Çini. His intention was to recreate the excellence of the *çini* of the sixteenth century that is named today for the town of İznik, though it was made in its own day in both İznik and Kütahya. Partnerships are volatile, fragile things in Kütahya. His four original partners and many of his students have left him, carrying the İznik Çini aesthetic into other shops, and Mehmet is the master of an atelier where he teaches bright young women, three of whom, he says, have surpassed him as painters of *çini*. Mehmet is a great teacher.

Mehmet Gürsoy endured criticism for naming his shop after another city, and for focusing so tightly on the works of the masters he calls his teachers: the dead potters of the sixteenth century. But their palette of six colors featuring a luscious red, and their harmonious floral designs, have become his own. Mehmet's goal, he said when he began, was not freedom or novelty, but excellence. Willingly accepting the restraints of tradition in order to learn, Mehmet narrowed his vision to force progress. By 1991, the works in his atelier were approaching the past in material quality, and by trading the loose handling of the old works for modern Kütahya's impeccable precision, Mehmet believed they had outstripped the past in painting. Another five years and the revival was complete. Basing his concept on the masterpieces of the sixteenth century, Mehmet first added flourishes that he called "aesthetic in the last degree," and then he exploded the old patterns across the surface of his plates. His dazzling, energetic works refer to the past but emphatically belong to the present, suiting the opulent decor of the Turkish middle-class home. Meanwhile, İbrahim Erdeyer has continued on his widening course, and Nurten Şahin has turned to the chests filled with Ahmet Şahin's old drawings. She has rededicated herself to the revival of Kütahya's designs of the earlier twentieth century, though she recombines them freely, renders them in the palette of the sixteenth century, and lifts their execution to dizzying new heights of exactitude.

Their styles are distinct. Going through a stack of plates from Kütahya, I do not have to look for signatures. As James Joyce said, the whole work of art is a signature. İbrahim Erdeyer paints in a solid, robust manner, like Ahmet Şahin's. Mehmet Gürsoy's plates dance with dainty detail. Nurten Şahin's works seem supernatural in precision, while remaining clean in overall look. Though he came late to the trade, a fourth artist has joined the others at the pinnacle of modern achievement. Kerim Keçecigil learned in Mehmet Gürsoy's atelier, but his designs and handling are more like Nurten's.

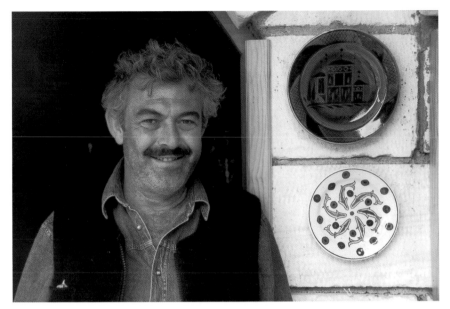

Sıtkı Olçar. Kütahya, Turkey. 1993

İbrahim Erdeyer and Kerim Keçecigil.
Kütahya, Turkey. 1998

Ahmet and Nurten, İbrahim, Mehmet, and Kerim form a circle of collegial exchange and contention at the heart of the art of Kütahya. And then there is Sıtkı Olçar. He is the most famous. Shows of his creations have been mounted from Japan, through Turkey and Europe, to New York City. Sıtkı keeps Kütahya's options open, going beyond old *çini* in the search for inspiration. Early in the 1980s, he refashioned designs from the freely-drawn earthenware of Çanakkale. In a moment of high excitement in the 1990s, he incorporated ideas from William De Morgan, painting plates with tumbling fish and preening peacocks. It was a witty act of reclamation, for De Morgan, the potter in the circle of William Morris at the end of the nineteenth century in England, had taken his inspiration from the masterworks of Turkey and Iran. As I write, Sıtkı is decorating *çini* plates with designs lifted from Byzantine mosiacs.

Self-taught and ebulliently independent, Sıtkı Olçar works in his day as Zafer Şahin did in his. Zafer, one son of the great Ahmet, kept his work free and fresh through constant change. He tried new things while the others tightened their effort to refine the received tradition.

Whether the goal is novelty or replication, when the masters of Kütahya concentrate on the work that must be done, the result — in their minds and mine — is certainly art.

Turkish artisans describe works of art as devices created in devotion and designed to lead the viewer, step by step, to higher understanding. First, the work pleases the body. Through the aesthetic, it appeals to the eye. Attracted into the work, the eye draws the mind behind it, and the work is revealed to be meaningful. Informed, instructed, the mind knows the world and arouses the soul to its beauty. The soul lifts in bliss and fills with love for God.

God is beautiful, the potters say, and God's beauty collects beauty. The first beauty of the *çini* plate lies in its material excellence — the smooth white body and gleaming clear glaze. These are the gifts of the master of the works, men like İhsan Erdeyer at

Süsler Çini. The second beauty is the gift of the painter who draws the outlines in suave sweeps and fills them with deep color.

Painters learn to "read" the design, to unlock its logic, while painting. After a couple of repetitions, the design has been mastered, and the artist is free to forget everything except the point at the end of the brush. Time stops. Creation is all. They call the emotion of that moment *aşk* — devotion, passion, love. Calm and intense in concentration, they give themselves in love to their work, and the work of art is, by definition, the object that contains the love of its creator.

The Western critic seems unable to see the passion in things unless they fuss for attention through innovative abandon and exhibitionistic deviance. But artists in Kütahya feel passion as an inner force that lifts them out of the common place and allows them to drive through meticulous craft toward a transcendent perfection. In Kütahya, the foundation of art is laid in a repetitive, ritualized state of meditative creation that brings natural substances through love into beauty.

The aesthetic quality of Kütahya's ceramics abides in technical mastery, in radiant materials and fastidious painting. Then, pulled through the eye by beauty, the mind is engaged by historical reference. In acts of revitalization, bringing the excellence of thirteenth-century Konya, fifteenth-century Bursa, sixteenth-century Kütahya and İznik, and twentieth-century Kütahya, into fresh being, the potters celebrate the tradition that was given, Mehmet Gürsoy says, as a special gift from God to the Turkish nation. In association with works from the past, modern Kütahya *çini* becomes a symbol for its creators and their patrons of the place they share: this city, this region, this grand country. The masterpieces of the sixteenth century, so dominant in the thinking of the potters, carry them back not only to a time of artistic excellence, but as well to a time of Turkish greatness, when the Ottoman Empire stretched from Morocco to Iran, from the Sudan to the gates of Vienna, and Turkish power was founded upon Islamic precept.

The wish for perfection, displayed in technical mastery, is part of the desire to unify with unity itself, the perfect order of the universe. The quest for perfection leads modern artists into connection with those artists from the past who received God's gift and bequeathed models of excellence to the future. Taking inspiration from old models, the artists make historical references in their own, but their vision lifts beyond history. Old works of art are, like the things of nature, like the cow of the Holy Koran, signs to guide life, and built upon personal passion, retrieving history, the artful ceramics of Kütahya achieve their highest significance in the sacred.

Modern works cluster into three main classes of design. One is calligraphic. Writing God's word in the Arabic script, the artist draws a prayer. The most usual text is the opening formula of the Holy Koran: In the name of God, the Merciful, the Compassionate. It is called the *Besmele*, and tradition says that the one who writes the *Besmele* beautifully will be blessed. The *Besmele* is a prayer for beginnings. It launches action with an appeal to God's mercy. Plates and tiles bearing the *Besmele* are commonly hung above the door to be the last thing seen, the last words spoken before entering the turmoil of the day.

In Ahmet Şahin's youth, Turks used the Arabic script, and he was able to create original calligraphic designs. Today's Turks use the Latin alphabet. The Arabic script, purified in sacred connotation, has become the possession of professional calligraphers in Istanbul. Understanding the complexities of the calligrapher's art, potters in Kütahya restrict their effort to making faithful copies of the works of great masters, both living and dead.

Nurten Şahin gained her first fame, and attracted many imitators, by creating two new designs for calligraphic plates. She took the general idea from Kütahya's recent tradition, refining it graphically while arranging a frame of arabesques around a rendition of the *Besmele* that was given shape by Ahmet Şahin. Her work is a prayer. At once it repeats the word of God and offers an homage to her husband's grandfather, her city's own master.

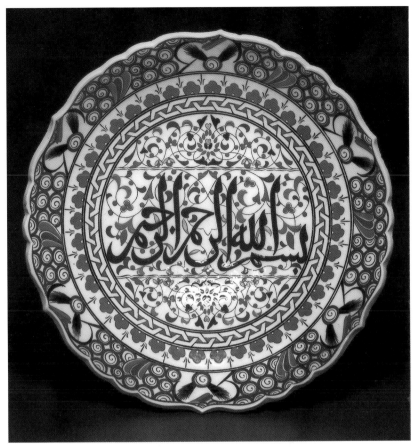

The *Besmele*. Plate by Nurten Şahin. 1993.
Collection of the Indiana University Art Museum

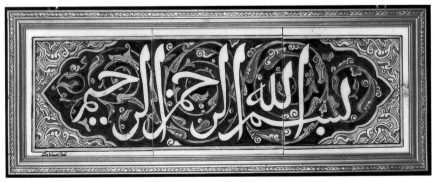

The *Besmele*. Tiles by Ahmet Şahin. 1990.
Collection of the Museum of International Folk Art

The second class of design is geometric. Wondrously diverse in detail, but one in structure, geometric designs are radially symmetrical. From a point at the center, the design expands in all directions, enfolding and controlling multiplicity in a single pattern — inscribed in a circle or pulsing toward infinity — that represents abstractly the totalizing, unifying power of the universe. While lecturing on Turkish art, I have found that Westerners generally believe that the Koran prohibits representation. Their own art leads them to feel that it is natural to make pictures of things, of the human form in particular, and only a restrictive ideology could have produced the aniconic qualities of Islamic art. But representation is not prohibited in the Holy Koran, and Islamic art is rich in representation.

They paint pictures of people in Kütahya. For Turks, they paint plates with portraits drawn from photographs. For foreign tourists, obsessed with the pictorial and charmed by the oriental, they fill busy plates with men on horseback, lifted from old miniature paintings. No hard rule prevents them from making pictures of people, but the masters consider them unimportant and consign them to the less talented decorators. Their sale supports the whole atelier, freeing the best artists to concentrate on the most important works. Those works are also representational. Calligraphic plates represent the word of God. Geometric plates represent the encompassing will of God. Theological presuppositions orient artistic actions differently. The Christian God made man in His image and appeared on the earth in human form, and the Western artistic tradition continues to fixate on the bodily. The God of the Muslim is without form. God's presence is imaged in words, in patterns, in signs.

The flower is a sign. The cycles of seed and blossom, blossom and seed, display, like the geometric design on the plate, the deep order of the universe. The bright flower on the dull landscape, like the star in the night sky, like the word revealed in the Holy Koran, attests to God's presence. It is a sign of the world's inherent beauty, of grace abounding.

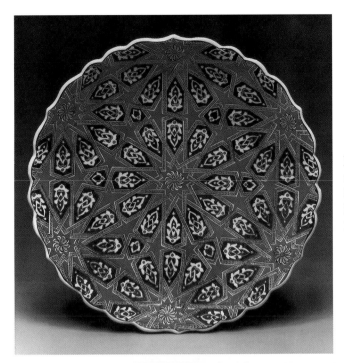

Plate in the design
of the interlocked star.
By İbrahim Erdeyer.
Kütahya, Turkey.
1994

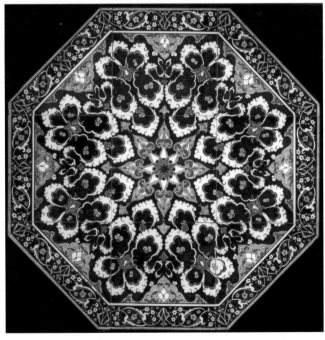

Tile panel. By Ahmet Hürriyet Şahin. 1994

Kütahya's third main class of design is floral. Calligraphic and geometric designs owe little to the magnificent *çini* of the sixteenth century. They are based on Kütahya's twentieth-century tradition, though they can also reach deeply into time. Written designs repeat the creations of the great calligraphers of the past, especially the sixteenth-century master Ahmet Karahisari. Geometric designs often overleap the Ottomans to remember the Seljuks of Konya, who shaped the first Turkish state in Anatolia during the thirteenth century. But today's floral designs are founded upon the masterpieces of sixteenth-century *çini*, and they make clear reference to nature.

The flower ornaments nature, as art ornaments the human environment. With amazing frequency, the world's artists match their art to nature's by choosing the beautiful, useless flower when they turn to decoration. Flowers accompany the statues of the deities on the altars of Buddhism, Hinduism, and Catholicism. Where no icon is worshiped, in Muslim, Jewish, and Protestant contexts, flowers still bloom on the face of art. The picture of a flower evinces an affection for nature, and flowers provide a worldly foretoken of the garden of paradise. Those ideas are raised by floral imagery, but the artists of Kütahya deepen meaning in subtle interpretation.

Mehmet Gürsoy tells us first to note that the flower is not realistic. Some are fantastic, dream flowers, but even when they are tulips and roses and carnations, they are solid and supernaturally perfect. The flowers on the plate are not the blossoms that wither and die on the hillside. They are not renditions of the transitory surface, shadowed in time, but revelations of eternal essences; they are to flowers as the soul is to the body. Made abstract to be symbolic, the flowers on the plate, Mehmet says, stand for human beings, not for their mortal bodies, but for their immortal souls.

Then note, Mehmet says, that all the flowers, though they are of different varieties, spring from one root. A clump of grass or a

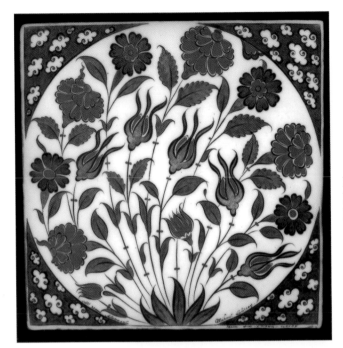

Floral tile.
By Mehmet Gürsoy.
Kütahya. 1993

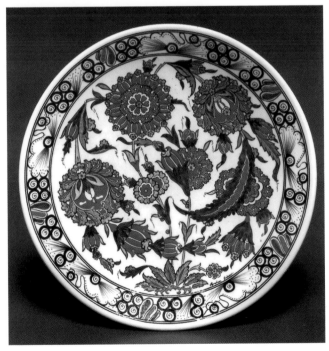

Floral plate. By İbrahim Erdeyer. 1994

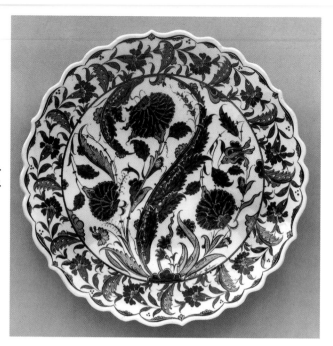

Floral Plate.
By Mehmet Gürsoy.
Kütahya. 1993

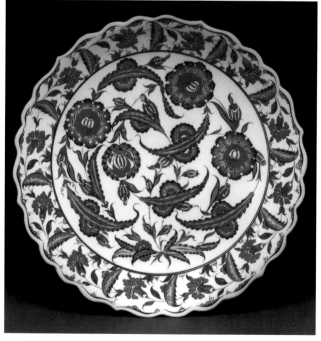

Floral Plate. By Habib Bakılan. Kütahya. 1993

dot of red, that root, he says, is a symbol of God's will, like the point at the center of the geometric design. We are not in the realm of mere botany. From one root, different kinds of flowers grow: some are tulips and some are roses, some are large and some are small, some are red and some are blue. And from the will of God, different kinds of people grow: some are women and others men, some are tall and others short, some are black and others white. Only God is one. Nature is diverse and imperfect. People are different at birth, and they are further differentiated by conditions. Some live long lives, others die young, and all are blown by the winds of chance. Mehmet's plate pictures the inner reality of existence. Beautiful forms lift from one root. They rise and sway and break in the wind, but together they shape a balanced composition within a perfect circle.

Balance, Mehmet says, is the key to the aesthetics of design. Accomplished most easily in symmetry, as it is on the geometric plate, balance is more challenging to the artist and livelier to the eye in asymmetrical configurations. On the floral plate, asymmetry signals worldly conditions, the winds that whip the garden, while the prevailing balance reveals the harmony that can be achieved when people live in accord with the deep rule of the universe.

Mehmet Gürsoy's floral plate exposes the inner order of life, the genetic and circumstantial differences among people, and it mounts a rhetoric for peace. Our differences are owed to God's will. Our lives unfold only within the compass of God's design. As different flowers form a balanced pattern, so should we, the people of the earth, cooperate in the creation of a beautiful whole. Mehmet's plate comes from love, and it asks us to love God by loving the others with whom we live, braving the storms of the moment in the circle of God's eternal love.

For Mehmet Gürsoy, work is devotion, and the work of art is a prayer — just as it is for Haripada Pal. Their religions seem complete in their difference. Islam is rigorously monotheistic and aniconic in its art. Hinduism is polymorphous and iconic in the

extreme. Mevlana Celaleddin Rumi, the great mystic of Seljuk Konya and a hero to the potters of Kütahya, teaches in one of his parables that different people — he specifically mentions Hindus, their tradition being so strange to the Muslim — have developed different styles of worship, but God understands the unity of love that lies beyond the difference of communal custom.

The Muslim potter of Turkey and the Hindu potter of Bangladesh both materialize their deep idea of the sacred in shaped and painted clay. The aesthetic is not incidental to their effort. It is essential. Both Muslim and Hindu potters bring the formless into form through beauty, and beauty serves society. The smooth, bright object attracts the eye and draws the soul in love toward God, and the soul commands the body to righteous social conduct.

Through common work, the potter of Kütahya comes into connection at the nexus of value, bringing material, aesthetic, social, and religious forces into union. Work eventuates in rich, shimmering objects and in lives that are happy enough — happy enough because daily labor brings personal integration (when physical, emotional, and intellectual capacities fuse in concentration) and social integration (when the artist works in a team to produce things that others actually want) and spiritual integration (when the creation accomplishes and portrays the self in the cosmos). Work brings the worker pride and power.

At the age of sixteen, Fevziye Yeşildere fills with worth because the works of her hands exhibit her skill, because they connect her to her teacher, Mehmet Gürsoy, and to her place, a city where elegant ceramics have been made for five hundred years. Even if scholars simplify their study and banish Muslim artistry to a dead past by attributing the finest old çini to another city — İznik, where the tradition died in the eighteenth century — her city's art, the kind she can make, has attained global recognition as one of the artistic treasures of humankind. Fevziye will not pursue the potter's trade when she marries and moves to Ger-

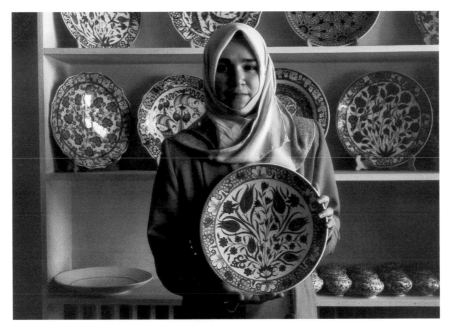

Fevziye Yeşildere displaying a plate she painted.
Kütahya, Turkey. 1994

Mehmet Gürsoy, İbrahim Erdeyer, Wanda and Marvis Aragon. 1991

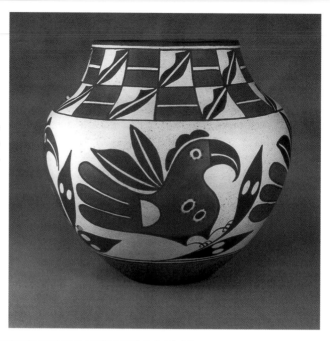

Parrot pot.
By Wanda Aragon.
Acoma, New Mexico.
1998

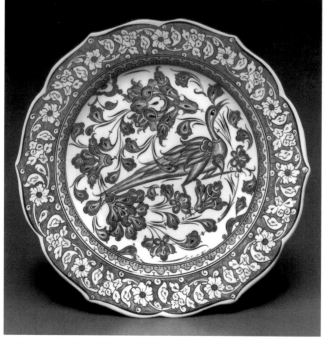

Çini plate. By Mehmet Gürsoy. Kütahya, Turkey. 1993

many, but she will not lose the strength she gained in her apprenticeship. She will become a woman of the modern world, but she will remain free of the debilitating anxieties that bedevil people who have never known creation in their own hands.

That is one purpose of art. It brings confidence to its creators. Those who make things know who they are. They have been tested and found competent. Then art exhibits value. The artist's creations act in the world, embodying the complexities of culture and shaping relations among people, between people and the environment, between people and the forces that rule creation.

The way that the potter's art contains value — and so communicative potential — came home to me clearly when I took Mehmet Gürsoy and İbrahim Erdeyer to New Mexico, where they attended the opening of an exhibition that I arranged of Turkish art and demonstrated their skills at the Museum of International Folk Art in Santa Fe. They were shocked at first by the high prices that sentimental people seemed willing to pay for Native American pottery that struck them as mediocre. Then we went to Acoma, to meet Wanda Aragon and Lilly Salvador, and their disappointment ended. They were thrilled by what they saw and excited to speak, through my translation, with their American colleagues.

The first thing they appreciated in the Acoma pottery was its material quality. The thin and even walls, as delicate as shells, demonstrated control over natural substances and technological procedures. Next they admired the brushwork. Like the Kütahya plate, the Acoma pot displays fine, smooth lines and a dense, unmottled fill of color. Lilly said she liked the bright colors of the Turkish plates, and she would like such a blue for her pottery, but she said she was obliged by religious stricture to use only natural materials. She had to content herself with gray and shades of buff and brown. Mehmet said he understood, but he was no heretic. He, too, ground minerals down and mixed them

with slip for his paint. They agreed on materials, they agreed on fineness of body and brushwork, and they agreed on design.

The Turks took the Acoma designs to be signs of sacred unity. Native Americans, they believed, were true Muslims. They had received the word in the days of the beginning and had held to the right path through time, though they did not know the Holy Koran. Acoma's pottery was not ornamented with trivial images from the transitory surface of things, with depictions of mere bodies. It displayed geometric designs that rotated endlessly to symbolize the unity of universal order. If the designs reflected the world through imagery, the figures were abstract, not naturalistic, and they were restricted in topic to flowers and birds. The Acoma pot might show a parrot, the bringer of water — a visualization of the potter's prayer for dampness. On the Kütahya plate, a fabulous bird — the flower of the air — often blends into the floral designs, symbolizing the artist who could fly free, disrupting harmony, but who chooses the moral option, melding into the social order and contributing to the world's need for loving and balanced behavior.

Wanda Aragon and Lilly Salvador, Mehmet Gürsoy and İbrahim Erdeyer: all practice the potter's art by selecting the best from the past and holding to old forms and techniques, by adjusting to their times with electric kilns, and by creating the future in traditional designs painted with an exactitude and innovative panache that surpasses their historic models. They come from places far apart and radically different in development. The Americans are women, the Turks are men. Their pottery is different in appearance but alike in its engagement with nature, its commitment to technical mastery, its respect for the past, its geometric and floral designs, its decorative presence, its commercial utility, and its submission to sacred power.

The potter's art brings us, through value, toward human unity as well as cultural difference. I have one more story to tell.

Japan

As Kütahya is to Turkey, Arita is to Japan. It is a city of potters on Kyushu where a Korean potter named Ri Sampei discovered kaolin early in the seventeenth century, and fine porcelain has been made from that time to this. Arita's porcelain, like Kütahya's *çini*, developed in response to Chinese porcelain but achieved, within half a century, its own distinct character.

Like the Pals of Bangladesh, the potters of Arita make both vessels and statues. That mix seems general in East Asia. Many of Japan's renowned centers for pottery — Bizen, Echizen, Hagi, Kutani, Kyoto, Mino, Seto, Shigaraki, Tokoname — also produce sculpture in clay. At Jingdezhen, China's city of porcelain, potters continue to shape images of the Buddhist deities. Potters at Dehua, China's second city of porcelain, made the creation of lustrous white figures into a specialty in the seventeenth and eighteenth centuries, and porcelain images from Dehua for sale in San Francisco's Chinatown attest to a modern revival of the old quality. Arita's statues, especially of Kannon, the bodhisattva of mercy, recall Dehua's works in their exquisite delicacy, witnessing to a continuity of Chinese influence upon Japanese porcelain.

Arita's main output is tableware: plates and bowls and cups. As in Kütahya it is graded, with a mass of cheap goods at the bottom and a clutch of masterpieces at the top. The finest plate or vase is marked by technical mastery and an attention to historic precedent. Japan is the world's center for ceramic revival. For centuries, Japanese potters, like Chinese potters, have copied and reinterpreted old masterpieces. In 1926, Soetsu Yanagi, Kanjiro Kawai, and Shoji Hamada — the last two of them potters — founded the Mingei movement. Built upon the negative reaction to westernization of the late nineteenth century, inspired by William Morris, and incorporating Buddhist concepts of selfhood, Mingei has pushed creation along certain lines, estab-

lishing a cultural climate within which potters in large numbers find worthwhile employment, and the process of revitalization is fostered. Many of those designated as living national treasures in Japan are potters who have experimented in our days to recover the excellence of past practice.

At Arita, some artists reproduce the heavily ornamented ware called Imari that was made in the past at Arita for export to Europe. Some artists work in the soft graphic style of the Chinese literati, and others in the two elegant styles developed in the seventeenth century to suit a Japanese sensibility: the solemn, aristocratic Nabeshima, and the spacious, brilliant Kakiemon.

About 1643, in the twentieth year of his family's work in porcelain, Sakaida Kakiemon used Chinese techniques to naturalize porcelain to Japan in open, asymmetrical designs and a range of bright color, featuring a sweet green and a rich red. A century earlier, potters in Turkey had similarly expanded upon the blue-and-white palette derived from Chinese porcelain, adding new hues, notably the green of grass in springtime and the ripe red of the tomato. And, as Kakiemon would at Arita, the Turkish potters applied their new colors to asymmetrically balanced designs that welcomed nature's beauties: flowers and birds. Late in the nineteenth century, and twice in the twentieth (in Ahmet Şahin's day and again in Mehmet Gürsoy's), the potters of Kütahya returned to the works of the sixteenth century for guidance, struggling to reachieve the white ground, vibrant colors, and transparent glaze of their tradition at its highest point. At the Kakiemon workshop in Arita, in the time of the twelfth and thirteenth masters in the Kakiemon line, a team assembled to rediscover the milk-white ground and gem-like colors of the seventeenth century. In 1953, they succeeded. One in that team was Sadao Tatebayashi, and in subsequent years, as a designer and the leading painter at the Kakiemon kiln, he achieved national recognition as an artist.

In 1978, Sadao Tatebayashi left the Kakiemon workshop and established his own kiln, where his son Hirohisa is the master

today. Across from his workshop, in his stylish showroom, Hirohisa has placed a photograph of his father, who died in 1992, and arranged around it an exhibition of his beautiful creations, building a museum to his tradition, much as Lars Andersson has in his pottery at Raus. Like Lars, Hirohisa is dedicated to preserving his teacher's standards, and as Wanda Aragon honors her mother and Haripada Pal honors his grandfather, Hirohisa honors his father in his work. Hirohisa has a box full of his father's designs drawn in pencil on paper, and he uses them, as Nurten Şahin uses Ahmet Şahin's, to create masterpieces that, like those of Matthew Hewell, incarnate his familial heritage, and, like those of the masters of Kütahya, bring the deep history of his city into new vitality.

Hirohisa Tatebayashi told me that there are one hundred and seventy workshops in the Arita area. Twenty percent of them, he says, resemble his in that they use hand techniques of shaping and decorating. None of those shops, he states calmly, make things more beautiful than his.

Hirohisa divides human endeavor into spheres, and envisions human accomplishment to be like a mountain range, rising to peaks of excellence. During our talk, he chose three spheres from life to illustrate his idea. In the realm of education, lazy students, wishing no more than jobs and money, study only at exam time and form a wide base of mediocrity, while a few true intellectuals rise to the heights of wisdom. The poor boy, unable to go to the university, might be doomed to toil in a noodle shop, but still a rare few strive to be the best and ascend to the top of the noodle shop business. Others are potters. Among the potters, most pass their days in dull labor, but a few dedicate themselves to greatness and climb to the summit of their realm of endeavor, becoming equal to the greatest professor or noodle shop man or political leader. Hirohisa's son learned his father's trade, but wishing more money than a potter can earn, he went to college to become prosperous and mediocre, while Hirohisa, by continuing his father's work and connecting through his father to the

great Kakiemon tradition, has risen, in his own estimation, to the very apex of ceramic achievement.

Hirohisa's concept sorts well with the thinking of Turkish artisans. The Western critic is tempted to give a simple answer to the complex question of what is art and what is not by identifying art with certain media, so that a painting is art, no matter how bad, and a pot is craft, no matter how grand. But the Turkish artisan considers the medium to be no more than a matter of fate. Some are born to be painters, others to be potters, some to be calligraphers, others basketmakers. While the artisans rank calligraphy as the greatest art and basketmaking as the humblest, they argue that what makes art is not the medium — not fate, but will: the dedication of the worker to excellence. Bad calligraphy is not art. Excellent baskets are.

Hirohisa Tatebayashi is willing to place himself among the world's best potters. Others are his equals, but no one is his superior, and yet he will not accept the name of artist. Artists, he says, are arrogant folk who wish it to seem as though they created in splendid isolation, away from the world and its people. Potters might be called artists when they work alone, digging their own clay, throwing and glazing it, but, Hirohisa says, porcelain is an art too complex to indulge individualistic urges or support egotistical claims. It takes ten years to learn the work of the wheel, ten years to learn the work of the kiln, ten years to learn glazing, ten years to learn to draw the design, and ten years to learn to fill it with color. No individual can have mastered the whole trade, so all must work as members of a team under the supervision of a master who understands the whole process.

Hirohisa's excellence lies in management, and he has assembled the best team possible. He has a young man who throws and trims the forms. Then Hirohisa operates the kiln, which was once fed wood but now burns gas. He fires the piece at nine hundred degrees centigrade, matching the peak heat in Kütahya. Then the biscuit ware is painted in blue by a woman who is one of the five decorators in the shop. This is a risk, because the piece

Hirohisa Tatebayashi and his daughter Chinatsu.
Arita, Japan. 1994

Porcelain plate from Hirohisa Tatebayashi's kiln.
Arita, Japan. 1994

receives much effort before it is given its highest firing. It is glazed with a solution of ash, crushed stone, and white glass, and then fired at thirteen hundred degrees. At that high heat, Hirohisa says, the fire gets down into the flesh of the pot. Then over the glaze the decorators add the outline and the infill of color, and the piece returns to the kiln for one or two more firings — it depends on the paint and the weather — at eight hundred degrees.

In the upright romantic critique, division in labor is lamented as a consequence of industrialization, but specialization is normal in any complex technology. Describing the work at Jingdezhen in the early eighteenth century, in the era of handwork when there were three thousand kilns in the city, a French missionary estimated that each piece of porcelain had absorbed the contribution of seventy people. In his astonishing early history of the Staffordshire potteries, published in 1829, Simeon Shaw wrote that specialization had increased with industrialization, when the potteries produced molded statues and sets of china for the English masses, but even in the days before 1760, when the potters wrought by hand in family shops, they divided the work among them by specialty.

So it was, and so it is in Kütahya. The plate that İbrahim Erdeyer paints was made of mud mixed by boys in his father's employ, and it was shaped, glazed, and fired by İhsan with the help of a team of young laborers. İbrahim signs his own name discreetly on the front, and he writes the name of his family's firm in large letters on the back. The gleaming porcelain vase by Hirohisa Tatebayashi was thrown by Chitoshi Matsuda, painted by Chizuko Shimimoto to a design by Sadao Tatebayashi, glazed and fired by Hirohisa, and signed with the name of their kiln.

As the manager of a team, the master of a kiln, Hirohisa Tatebayashi stands higher than the artist. And that is how it is in Turkey. The artist, the *sanatkâr*, creates beautifully, but the master, the *usta*, does more. The masters are artists. They create. But they also manage a workshop, and as part of their managerial duties they teach, standing in a parental role to their workers,

guiding them to correctness in art and life, and running the business on which their livelihoods depend. One can claim to be an artist, but only society grants the higher title of master. The artist is talented. The master is talented and socially responsible. The wild artist might achieve the highest prestige in individualistic societies. But in the mature society, to be the master of a pottery is a finer thing.

In Japan, the master of a pottery is called *sensei*. The same title is given to teachers in schools. The educational implications of the terms *sensei* and *usta* fit ateliers like Hirohisa Tatebayashi's in Arita or Mehmet Gürsoy's in Kütahya. As Mehmet emerged as an artist in the eighties, he told me his goal was to become the loving master of a workshop. He would teach and his students would become his hands, performing to his will. His goal has been met. When we tape-recorded his life history, İbrahim Erdeyer said he wished to be remembered, not as an artist or businessman, but as a teacher. At Seto in Japan, Hiroshige Kato, the twelfth in the familial line of masters at the Kasen Toen, proudly told me that his vast workshop admitted young people and instructed them, giving them practical experience before they left to follow the chance of their own careers.

Contrasting the pottery of Kütahya with the painting of Europe, Ahmet Şahin said that traditional arts, like his, rarely accomplish shocking novelty, but they rarely fail. Quality is steady, and one reason is the system of the atelier. The atelier is an educational institution, training young workers who leave to seek better jobs, circulating through the community, renewing and unifying the general tradition while preventing stagnation and preserving standards. Split by specialization, housing experts in every phase of a complex technology, the large atelier serves the community's artists who work alone. Early in the eighteenth century, Kenzan Ogata could rely for forms and firing on the masters of Kyoto, and in the middle of the twentieth, Ahmet Şahin was supported by the masters of Kütahya. He took biscuit ware from the workshops, painted the pieces to his own designs, and then

returned them for glazing and firing to masters like İhsan Erdeyer at Süsler Çini. It was an honor to serve the artist who served the city through the creation of new and inspirational works.

Success in the cities of Arita and Kütahya depends on the efficient management of the masters. But in even the largest shop, managerial and educational duties are not divorced from creative action. Hirohisa paints and fires. İhsan throws and glazes. As surely as the commander of an army must have known battle and risen through the ranks, as surely as the effective administrator of a university must have taught and conducted serious research, the master of a pottery must have worked in the mud, learning the entire process and coming to know what the workers can do — when they need instruction and when they must be left alone to practice freely. Excellence in creation demands decisions that, grounded in intimate experience, properly mix direction and liberation. It is necessary to manage, natural to teach, but what is central to mastery is creation.

Hagi

Hagi is a trim, bright city in the far west of Honshu, on the shores of the Sea of Japan, across from Korea. In the city and its environs, two hundred shops produce Hagi *yaki*, the region's distinctive ware. Few of them are large operations, most are small, and the one I will tell you about is Norio Agawa's, on the banks of the Hashimoto River. When I was there once, a man delivering a load of clay said he addressed the manager of every shop as *sensei*, but Norio Agawa is really a *sensei*. No apprentices await his direction. He deserves the title of respect because of his intense creative energy.

Norio Agawa is not exactly alone. His sunny shop bubbles with the chat and cracks with the laughter of many visitors. He glazes and fires the creations of his brother Hachiro Higaki, who learned from him. His sprightly wife, Motoko, finishes some of

Hachiro Higaki. Hagi, Japan. 1998

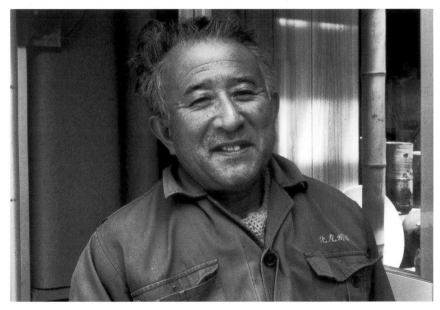

Norio Agawa. Hagi. 1994

the pieces and helps in loading the kiln. But Norio Agawa sets the shop's quick tempo, and he does it all with his own hands, mixing the clay, shaping, glazing, and firing it.

He does the work, and he taught himself. Teaching, he says, is not important. Learning is. When he married, he was adopted into a family that had been making roofing tiles for ten generations. His wife's father gave him his first lessons in the clay, and many others have provided hints along the way. But Norio Agawa is his own teacher. The masters, he says, will not teach the important things. They guard them jealously and transfer them clandestinely within family lines, though even to their own sons they cannot teach the things that matter most, for they have become lost into old habits beyond the reach of the conscious mind. Only simple things can be taught. Complex things must be learned on your own. So, you study the works of the great masters, then experiment to discover how they were made, and, at last, you teach yourself by doing. Talent is necessary, Norio Agawa says, but the key trait is will, the drive to keep at it until failure converts into success. Mastery comes from getting to know the clay in your hands, from making things repetitiously in great numbers.

Differences in organization and education are only the beginning of the differences between a one-man shop like Norio Agawa's in Hagi and an atelier like Hirohisa Tatebayashi's in Arita. When I stayed with him, I brought as a gift a plate painted by Nurten Şahin. Norio Agawa tapped it, commented that it was low-fired, and then said that other than that it was like the ware of Arita. Its artistry lay in its painting. His artistry, he said, lies in the shaping of form, and he divided all of pottery into two kinds. One is like Arita (or the Kütahya of Nurten Şahin), in which pottery provides a bright foundation for a display of decorative virtuosity. It is a painter's art. The other is like Hagi (or the Raus of Lars Andersson), in which decorative qualities are inchoate in the production of form. It is a sculptor's art.

Hagi's tradition began when the lord of the Mori clan brought two Korean potters to the city at the beginning of the seventeenth

century. The aristocratic fashion of the tea ceremony was at its peak, and with those potters Hagi became, and remains, a center of production for tea vessels: teabowls and tea canisters, containers for incense, fresh water, and flowers. Hospitality is the prime principle of the tea ceremony, I was told by Kaneko Nobuhiko, a potter in Hagi, but the tea way elaborated in exchanges between the palace and the monastery, and it deepened in the context of Zen. Framed by the philosophy of Zen Buddhism, the tea ceremony raises antinomies, not for synthetic resolution in the Western manner, but so that differences might coexist in tension and the complexity of the world might be known. Simple hospitality is governed by an intricately complex etiquette. The setting is deliberately humble and rustic; the actions are mannered, courtly, and elegant. The frothy green tea is bitter; the small round cake is sweet. The company is pleasant and tranquil; the moment is melancholy, suffused with an awareness of time's passing and the transience of things.

Millions in modern Japan practice the cordial discipline of the tea ceremony. Their vessels must not seem luxurious. They should recall the imperfections of nature and the potter's labor, and yet they must fit an exquisitely refined aesthetic. In making tea ware, enacting his city's old tradition, Norio Agawa moves at every step along a path unlike the one that leads to the smooth beauties of Arita. But his course is no less sophisticated. Out of a distinct sensibility, he creates objects that are profoundly informed by the Buddha's understanding of the nature of the world.

At Arita, the struggle is to achieve an unnaturally flawless, luminous white body, in no way reminiscent of the earth. Norio Agawa commences with two kinds of clay, red from an island to the north, yellow from the hills to the south. The yellow can be used alone, but the red must be mixed to take form. The clays might be fused loosely to produce streaks of natural color, like the marbled ware of England. More often they are blended thoroughly in different proportions. What is most remarkable is that when Norio Agawa blends them, he adds the fine gravel that

was removed from the clay during its process of purification. He returns a natural roughness to the body. His works carry the mottled, subtle hues of the earth and the gritty feel of the soil.

Patting the clay into a soft cone, he centers the lump on the wheel and throws off the hump in the Asian manner, like potters in Bangladesh, shaping form after form from the tip of the spinning mass. He cuts the bowl free, carefully preserving the tracks of his fingers that would be fastidiously shaved away at Arita. It is proverbial in Japan to say that, for tea ware, Raku is first and Hagi is second. The Raku teabowl is made in Kyoto without a wheel. It is pinched into shape, then carved. As his teabowl dries, Norio Agawa might add a Raku touch by slicing angular facets in the lower body, diminishing the regularity of the wheel-thrown form. He completes the bowl by chopping in the notched footring that is emblematic of Hagi's ware.

During its first firing at seven hundred degrees centigrade, the bowl might gain smoky burns, and Norio Agawa adds dark passages with splashes of gray slip before glazing. After the second firing at twelve hundred and twenty degrees, the glaze, a mix of feldspar and ash, will sheathe the shape with transparent brightness. It will turn white in streaks to contrast with the buff and gray beneath and with the matte tones of the clay, displayed low on the vessel where it was washed to prevent the glaze from adhering.

Potters in Hagi strive for two special effects. One comes from firing. By controlling the flow of air and preventing the kiln's atmosphere from settling into a state of either reduction or oxidation, they achieve accidental ornamentation: a dappling of yellow spots, nimbed with pink, upon a field of gray — a look that is likened to the pelt of a fawn at the Asahi Pottery in Uji, to fireflies at twilight in Hagi. Hagi's signal effect comes from the "rice straw white." Norio Agawa gets rice straw from neighboring farmers. He burns it, not to ash, but to charcoal, and mixes it with his usual glaze to get a thicker, richer white. Timing is all: the vessel is gripped by the footring, dipped quickly to coat the exterior, popped up at the surface to fill the interior, swished

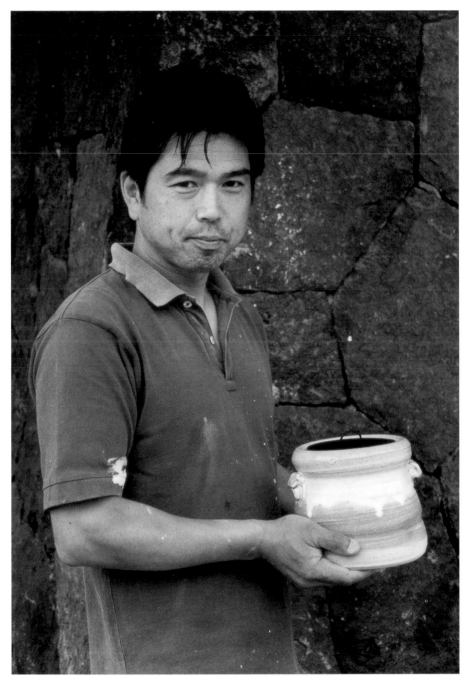

Kaneko Nobuhiko holding a water container for the tea ceremony, glazed with the rice straw white. Hagi, Japan. 1998

Tea canister,
with rice straw white glaze.
By Kaneko Nobuhiko.
Hagi, 1994

Firefly teabowl.
By Seichi Sakakura.
Hagi, Japan.
1998

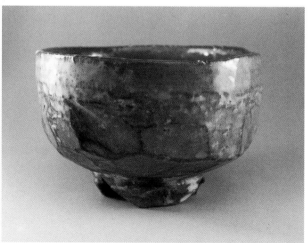

Teabowl. By Norio Agawa. Hagi. 1998

back and forth to thicken the glaze at the rim, and then flipped over suddenly to let thick vanilla drips ooze sumptuously over the light coat beneath, white upon white.

Turned for lifting, the teabowl is savage at the base — rough as though ripped from the earth. It rises from sharp edges toward smoothness on the sides, where the hands nestle into the grooves left by the potter's fingers. The clean rim awaits the lips.

With its drips and puddles of satiny white and its rippled, gritty surface, Hagi's ware is a celebration of contrast: it is natural and artificial, controlled and accidental, regular and irregular, rough and smooth, dark and light, shiny and dull, earthy and ethereal. It is like a white cloud descending upon the face of a rocky cliff, or a snowfall on broken ground, or — this is better, given the city's setting by the sea — it is like seafoam adrift on a gravelly beach. Whatever the figure, it needs to fit the Zen tradition, assembling difference and evoking evanescence.

The Hagi style is materialized most dramatically in creations for the tea ceremony. It is subdued, but sustained, in the ware Norio Agawa makes for daily use. A snowy gloss flows down the dimpled, granulated surface of his teapots and cups. His rice bowls come blushing or dove-gray from the kiln.

The potter's performance begins, but does not end the process of creation. Seichi Sakakura, a friend of Norio Agawa's and a maker of tea ware, says that if you place a pot out of touch on a shelf, it weeps, crying to be used. The one who uses it becomes, he says, a new creator as the teabowl continues its existence, transforming through seven stages. With use, the thick white glaze crackles. This is another of Hagi's effects that is at once intentional and accidental, technological and ornamental, for the potter refined the clay so that the emergent web of cracks would suit the vessel, a fine web for small forms, a looser for larger. Then stains grow around the grit. Dark streaks appear. In time, darkening like a storm cloud, the bowl will be broken and repaired with lightning flashes of gold lacquer. Through every phase, in use, the bowl approaches its destiny and in-

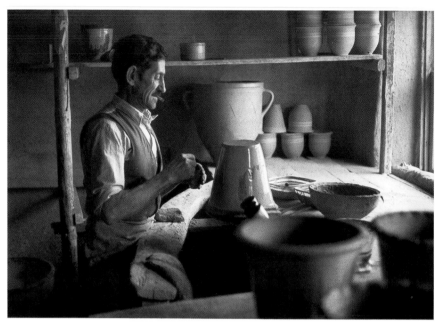

Mustafa Baydemir. Kınık, Bilecik, Turkey. 1985

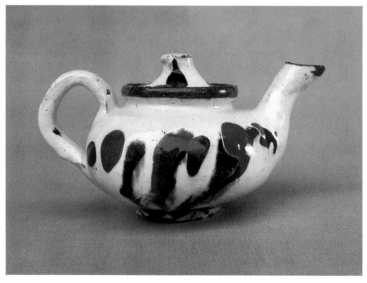

Teapot. Kınık. 1990

creases in value, that value lying in its ability to display the reality of the world: the irreconcilable differences, the inevitable decay.

At Arita, the potter's art yields an object beyond time, made in complete control and mysteriously perfect. At Hagi, the potter's art invites contradiction and accident. In its thrown, burned, and stained fabric, the artifact tells the tales of its making and use. It belongs to time. Japanese taste widens to embrace both styles, the one transcendent, the other transient. As they have since the seventeenth century, Japanese potters shape beautiful vessels to radically different aesthetic ends.

Turkish taste displays a comparable breadth. Kütahya's *çini* is like Arita's porcelain in its meticulously painted, gleaming white forms — in its will to control — but the earthenware tradition of Turkey welcomes happy accidents. In the recent past at Çanakkale, jars and bowls were splashed with drips and swirling spatters that recorded the artist's spontaneous gestures, much as canvases by Jackson Pollock do. At Kınık, a village with one hundred and fifty workshops in northwestern Anatolia, the potters dip their jugs and flowerpots in a vat of white slip, and then return them to the wheel. Nudged with a kick, the wheel turns while the slip slides, and the potters drop dots of color or run a spiral of tinted slip into the moving surface. The slip flows, the spiral drifts, distorting to take on the semblance of wavy wood grain, and its descent is hastened by drips tipped from a tin horn. Mustafa Baydemir learned the craft from his father in the 1930s, and he decorated hundreds of pots a day until his death in 1992. No two of them, he said, were the same. Mustafa's art was an art of uncontrol. A participant in the force and counterforce of the universe, he began the process, wedding damp substances in the context of gravity, and then he left completion in the hands of God.

In Hagi, intended accidents are framed by a Buddhist vision of imperfection. At Kınık, intended accidents are framed by the Muslim tenet of submission. Both wares befit the human and

belong to the bump and chance of common life. Both are implicitly religious. Through the aesthetic they whisper of the sacred. Then the sacred becomes manifest in representation. In Turkey, the tile or plate of Kütahya is calligraphed with the word of God. In Japan, at Hagi, the potter makes statues.

At the end of the seventeenth century, the great Shinbei Saka pressed Hagi's repertory beyond tea vessels to include sculpture, and before his death in 1968, Geirin Nakano astonished the city with gigantic ceramic images of the Buddhist deities. Many of Shinbei Saka's works remain in museums. Norio Agawa has studied them closely. Once he went to meet Geirin Nakano, but the master would not speak with him, and Norio Agawa has had to figure out sculpture for himself.

The easy way to make a statue, he says, is to take a lump of clay and shape the form by addition and subtraction. The statue of the goddess in Bangladesh is made by packing clay around an armature of wood and straw, then adding clay and carving it away. While the *murti* dries slowly, cracks are filled, and the surface is smoothed with watery layers that prepare it for painting. That technique was used in ancient Japan. It probably came from India through China with Buddhism, and clay statues, technically like those of Bengal and more than a millennium old, remain in the temples of Nara. But those statues were not fired. Even if the flammable core were omitted, such statues would be unsuitable for firing, Norio Agawa said, because differences in the thickness of the walls would lead to cracking in drying and explosions in the kiln.

The solution in Bangladesh is to use molds when images are to be fired. The clay can be pressed into the mold to a steady depth, and the mold will hold the form while it dries. In Hagi, Geirin Nakano used molds for his smaller works, and the master at his kiln today, the marvelously talented Takuo Matsumura, uses his old molds to get new forms that, like the most conscientious masters in Bangladesh, such as Maran Chand Paul in Dhaka, he finishes with painstaking handcraft. But Norio Agawa be-

Takuo Matsumura. Hagi. 1998

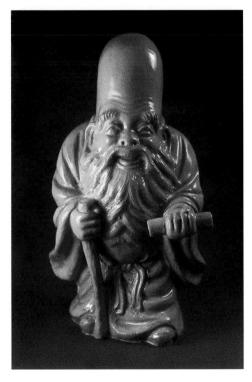

Jurojin,
a god of wisdom.
By Takuo Matsumura.
Hagi, Japan.
1998

Shoki.
By Norio Agawa.
1994

Daruma.
By Norio Agawa.
1998

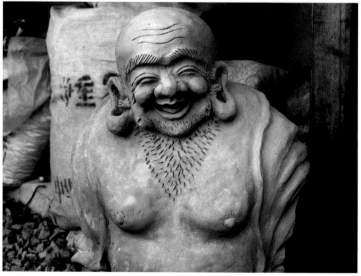

Hotei. By Norio Agawa. Hagi, Japan. 1994

lieves, like Haripada Pal in Dhaka, that molded statues lack life. It takes, he feels, the direct touch, the free-wheeling gesture of the moment, to bless a form with vitality, whether it is a teabowl or the image of a god.

Norio Agawa told me that if you can throw a tea cup on the wheel, you can do anything, and he has developed a way to make statues as though they were pots. His technique is akin to the process used by Native American women, or the Raku potters who raise vessels without wheels. But — and that is, believe me, a big but — instead of circling, pinching, and smoothing clay into symmetrical, spherical forms, he arranges it asymmetrically around the hollow shapes of bodies. It takes deep knowledge of the clay to build forms to the point where the walls want to collapse, to let them dry, just enough, and then to add more, quickly, carefully enclosing the void with a damp, flexible cover that is even in thickness. It takes knowledge, and still more it takes imagination, the mental powers of a great designer, to know how to plan and then fashion a coat of clay around nothing into a vivid representational image. While he works, Norio Agawa takes advantage of his different clays, modeling faces and hands out of the yellow, sweeping robes out of the red, and he ends with a flurry of emphatic, deep incising that charges his expressive figures with his own high-voltage personality. Firing, glazing, and firing them again, just as he would a cup or a bowl, he brings a last layer of life to the statues that stand, glowering and grinning around his workshop.

His images are not intended for temples. Only rarely does Norio Agawa sculpt the icons — the Buddha seated in stillness, Kannon swaying in grace — that are found on public altars. His works fit the decor of the home and garden. They belong to the auspicious, protective order of domestic religion. His repertory is centered among the Seven Gods: Hotei, Benten, and Bishamon, Daikoku and Ebisu, Jurojin and Fukurokuju. Diverse in origin — Buddhist, Hindu, and Taoist — they have been grouped since the fifteenth century and imaged for home consumption in ev-

ery medium, including ceramics, throughout Japan. These are the deities of good fortune, of longevity and prosperity, who bring music and learning and wealth to balance the sorrow of life. Norio Agawa chooses most often to represent the merry, fat Hotei. A Zen priest in the tenth century, Hotei is a lucky god, always smiling, his bag always full, and he is a bodhisattva, big with compassion for human suffering.

Stretching to collect influences, while attending to the models left by Hagi's old master Shinbei Saka, Norio Agawa shapes familiar images with wit and warmth. His brother Hachiro Higaki turned to the clay after a career in the merchant marine. He learned Norio's techniques, and he has worked to give some among the Seven Gods a new and peculiarly Japanese cast. When he builds Fukurokuju, a god of longevity, he usually models him to the Chinese figure, but he has also developed a new depiction — no one, Hachiro says, knows what the gods look like — that borrows the brooding mood of Daruma, the monk who brought Zen to China in the sixth century, and who frequently gains monumental presence in Norio's hands.

Norio Agawa constructs images of Japanese heroes and Buddhist deities, but his life's goal is to make the best lion of our days, just as Shinbei Saka made the best lion of his. No extant lion struck him as right, so he embarked on a campaign of research, trading for a molded lion by Geirin Nakano, taking snapshots of old lions, then selecting bits from those he saw and combining them into a lion that is all his own.

The lion is the guardian of the Buddha's way. Lions stand at the entries of temples. For centuries, the citizens of Hagi have bought new lions when they built new houses, placing them in the alcove within, next to the familial altar, where they protect the home from evil and help to keep its occupants on the righteous path of the Buddha. Lions come in pairs. The mouth of the lion to the right is open, the mouth of the one to the left is shut. It is the same with the lions that flank the path to the temple, and with the heroic gods in human form who rage inside the temple's

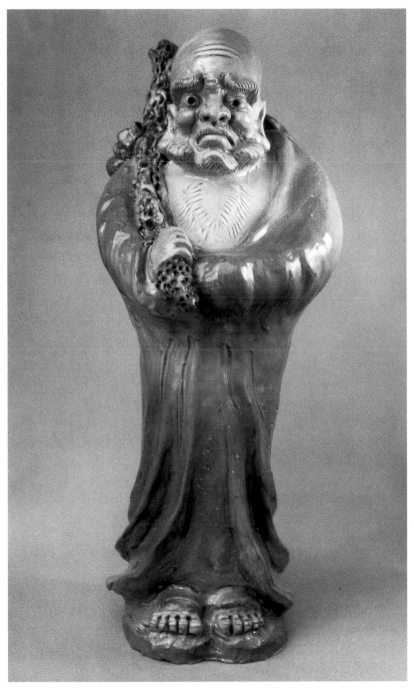

Fukurokuju. By Hachiro Higaki. Hagi, Japan. 1996

Norio Agawa
at work on a lion.
1998

The lion
in its first phase

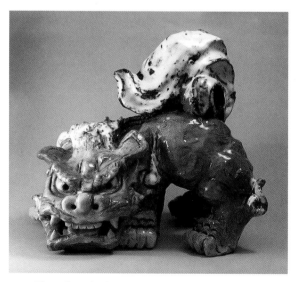

Glazed with the rice straw white and fired.
By Norio Agawa. Hagi, Japan. 1998

gate, and with the horned demons who glare from the rooftop. The lion of the right opens its mouth to say the sound of the beginning, from which enlightenment flows. The lion of the left closes its mouth to murmur the sound of the end. They speak the sounds of time, separately expressing difference — the female and male, the violent and benign, the start and the finish, existence and extinction — and together they enunciate the syllable of eternity — om — recalling the place beyond duality, the pure land that abides beyond the world of difference and desire and history.

Norio Agawa works to fulfill his dreams. Pottery is his delight. He makes vessels for the tea ceremony: teabowls, cases for incense, and vases for flowers. He makes cups and bowls for daily use, and he drinks his morning tea from a darkening cup that came from his own hand. He uses the same gritty clay to craft images of the gods and of the lions that guard the Buddhist household.

The circle closes, our tale is told. Like the potter of Bangladesh, Norio Agawa meets the needs of the people with utilitarian ware and sacred statues. The big difference is that he lives in Japan, where tradition is treasured like a dewdrop on a maple leaf in autumn, where the economy, despite talk of crisis, remains miraculous. The effort that brings him personal joy, that eventuates in service to others, also brings him a comfortable living: a big house with a lovely view, two new cars, and an immense, space-age television set.

His seventieth year approaches, but he puts in a long day, every day. Vacations, he says, bring him no pleasure. Work is what he likes, and within work, diversity. He brings a small lion to the end of its first phase, where it must rest and dry, and he shifts quickly to a gigantic lion on a second turntable, sharpening its ferocious snarl and the bristling curls of its mane, until it, too, must wait. He does not stop. His creatures are maturing relentlessly on their own schedules. Holding time's erratic pattern in mind, he switches to another task, pounding, patting, and centering a hillock of pale clay on the wheel and throwing the tall tumblers that were ordered by a customer from the other end of

the country, in Tokyo. The board beside him crowds with fresh, pert forms. He looks up at the big clock on the wall and declares it time to quit. The Giants battle the Carp on the box tonight. He will pour himself a tall vodka and milk and relax with baseball. Now it is time to stop. He lifts the board, slides it into the drying rack, centers another lump, and begins again, pulling elegant forms out of the whirling tower of clay.

Work in the Clay

It is good to be a potter. At work, the potter manages the transformation of nature, building culture while fulfilling the self, serving society, and patching the world together with pieces of clay that connect the past with the present, the useful with the beautiful, the material with the spiritual.

The one who can do all that does enough. The potter has won the right to confidence.

Confidence, stability, quiet pride, easy cheer — these are what I find in the masters of ceramics. They pause to welcome me, then turn back to the work that is their job, their duty, their pleasure. Differences of culture and personality recede into unimportance as potters join in calm intensity, finding what it is to be human through work in the clay.

Writing is my craft. It is not more or, I guess, less important than pottery, and practicing it I have been aided by the example of the potters it has been my good fortune to know: Ahmet Şahin, the old master of Kütahya, described by Mehmet Gürsoy as the deeply-rooted tree of which Mehmet and his friends are the branches; Mehmet Gürsoy, who remembers Ahmet Şahin and the masters of sixteenth-century Turkey in creations that situate his personal energy in God's design; İbrahim Erdeyer, Mehmet's friend, who proves that one can be an artist and a thoroughly good human being; Nurten Şahin, who went as a beautiful young woman into the rough world of men and gained their admira-

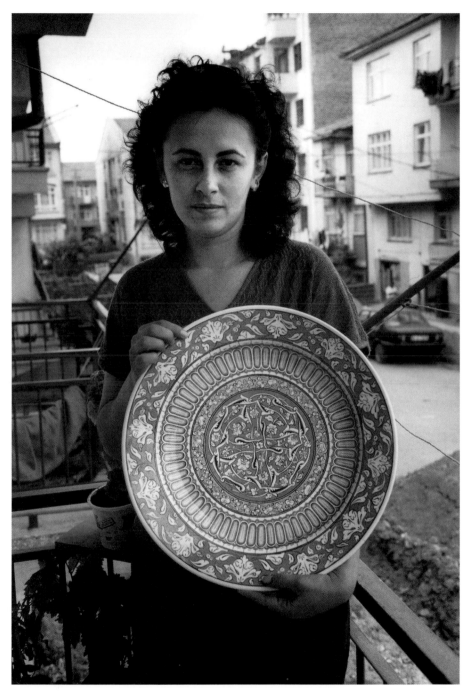

Nurten Şahin. Kütahya, Turkey. 1993

Wanda Aragon.
Acoma, New Mexico.
1998

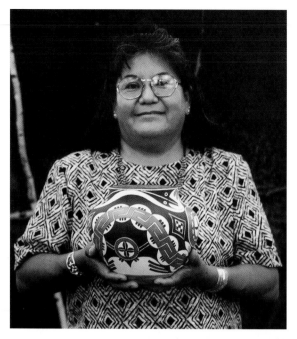

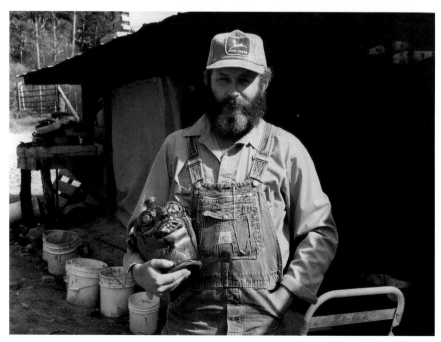

Chester Hewell. Gillsville, Georgia. 1999

tion for her skill; Hirohisa Tatebayashi of Arita, who disdains the name artist because it obscures the collaborative reality of ceramic production; Norio Agawa of Hagi, whose teabowls endure, whose statues of the gods overspill with his own high spirit; Kaneko Nobuhiko, Hagi, Japan, who intends his works of art to become part of the give and go of common life; Irene Aguilar, Oaxaca, Mexico, whose images of Christ's mother rise serenely out of the tawdry market for souvenirs; Dorothy Auman, Seagrove, North Carolina, practitioner and historian of her tradition, who made the redware plates we use on festive occasions, remembering her; Chester Hewell, Gillsville, Georgia, son and father of potters, who both manages a big factory and turns and burns his region's pots in the old-time way; Mark Hewitt, son of the director at Spode and student of Michael Cardew, now blending the Mingei concept with North Carolina's old tradition into something monumental and fresh, useful, beautiful, and old as hope; Wanda Aragon, Acoma, New Mexico, whose works are the ultimate refinement of her hard environment; Lars Andersson, Raus, Sweden, whose pots beckon the past into burned earth; Haripada Pal, Dhaka, Bangladesh, whose labor is wrapped in philosophical discourse, whose work in the clay is a hymn to God.

I am not a potter. I am a folklorist, a student of ceramics because pottery is a more universal and democratic medium than painting, a better place to begin the search for the world's excellence. I have become an admirer of the maturity of the sincere worker with clay, and I envy the options of the modern potter.

Seizing upon the immanent artfulness of pottery, the potter can withdraw into isolation and ascend along the arc that ends in a transcendence of consciousness. Or, through the earthiness of technique and the compound significance inherent in the committed rearranging of the world, the potter can join the millions remaining on the earth whose daily work brings them, roughly, directly, into awareness of their position in the cosmos.

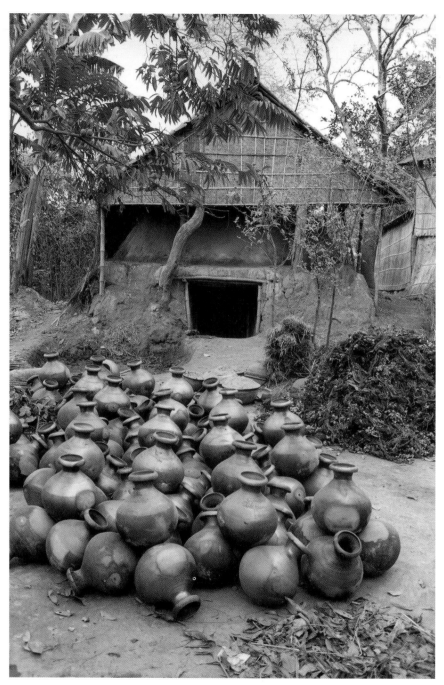

Kiln and *kalshis*.
Norpara, Shimulia, Bangladesh. 1996

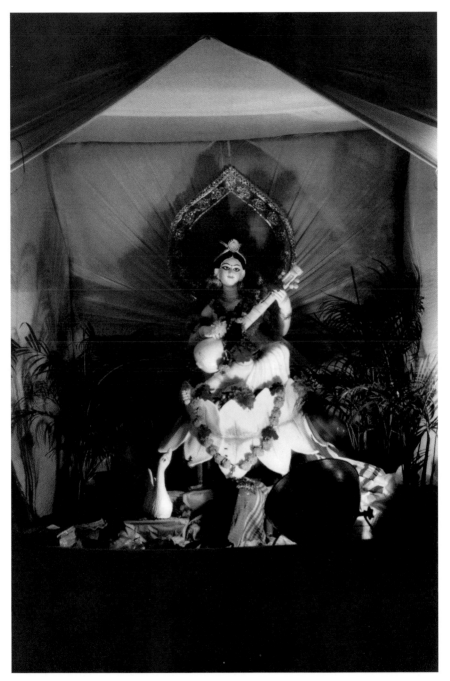

Saraswati. *Puja* at Dhakeswari Mandir.
Dhaka, Bangladesh. 1987

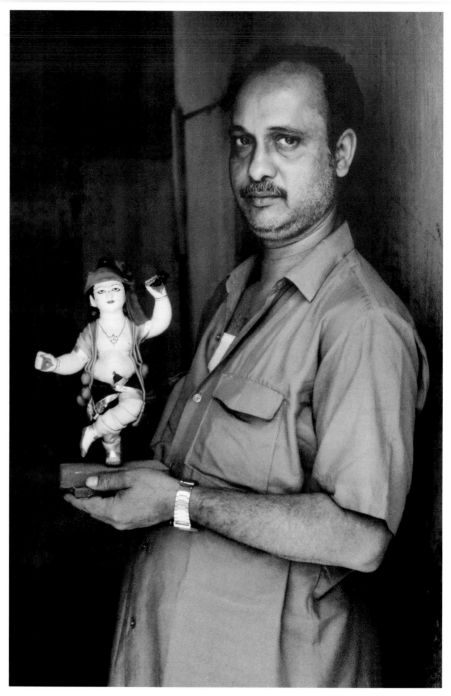

Haripada Pal. Dhaka, Bangladesh. 1995

ACKNOWLEDGMENTS

Based on work in the field, this book puts me happily in debt to the potters I know. Among them, I wish to state my gratitude to these especially: Marvis and Wanda Aragon, Linda Arbuckle, Dorothy Auman, Chester Hewell, Matthew Hewell, Mark Hewitt, George Johnson, C.J. and Billie Meaders, Don McCance, Lilly Salvador, and Jim Tanner in the United States; Lars Andersson in Sweden; Habib Bakılan, Mustafa Baydemir, Selma Çekiçoğlu, Muradiye Çelik, İbrahim Erdeyer, İhsan Erdeyer, Hakkı Ermumcu, Mehmet Gürsoy, Osman Kaya, Kerim Keçecigil, Saim Kolhan, Nursel Okur, Sıtkı Olçar, Ahmet Şahin, Ahmet Hürriyet and Nurten Şahin, Faruk Şahin, Zafer Şahin, Abdülkadir Uçaroğlu, Saadet Udül, Sabri Yaşar, and Çiğdem Yıldırım in Turkey; Mohammad Ali, Sankar Dhar, Amulya Chandra Pal, Babu Lal Pal, Fulkumari Pal, Gauranga Chandra Pal, Haripada Pal, Jatish Chandra Pal, Lal Chand Pal, Santosh and Govinda Chandra Pal, Shachindra and Saraswati Pal, Sumanta Pal, and Maran Chand Paul in Bangladesh; Norio and Motoko Agawa, Hachiro Higaki, Ryoji Kajikawa, Hiroshige Kato, Susumu Kato, Takuo Matsumura, Kaneko Nobuhiko, Seichi Sakakura, Hirohisa Tatebayashi, and Katuko Tokunaga in Japan.

Fieldwork is the least lonely endeavor. I have enjoyed the company of dear friends in the field: John Burrison in Georgia, Karen Duffy at Acoma, Orvar Löfgren in Sweden, Shafiqur Rahman Chowdhury, Shamsuzzaman Khan, and Firoz Mahmud in Bangladesh, and Takashi Takahara in Japan.

Writing a book on pottery, I gain my place in a circle of friends who have produced an admirable body of knowledge on traditional ceramics: John Burrison, John Carswell, Susan Isaacs, Ralph Rinzler, Nancy Sweezy, and Terry Zug.

My way to pottery has been developed in collaboration with my masters and colleagues in the movement for the study of material culture. With gratitude and affection, I must first name Fred Kniffen, then Robert Plant Armstrong, James Deetz, E. Estyn Evans, James Marston Fitch, and Warren Roberts, and then these friends with whom I have worked to bring meaning to things: James Ayres, Alison Bell, Simon Bronner, John Burrison, Walter Denny, Karen Duffy, Bernie Herman, Marjorie Hunt, Jason Jackson, Mike Jones, Suzi Jones, Sung-Kyun Kim, John Kirk, Peirce Lewis, Jiang Lu, Firoz Mahmud, Seth Mallios, Howard Marshall, Don McTernan, John Moe, Baqi'e Badawi Muhammad, Peter Nabokov, Jerry Pocius, Jules Prown, Ralph Rinzler, Bob St. George, Takashi Takahara, Dell Upton, Serena Van Buskirk, John Vlach, Mats Widbom, Wilbur Zelinsky, and Terry Zug.

This book exists because John Gallman encouraged me to write a general book, *Material Culture*, published by the Indiana University Press in 1999. My companion in travel, my brother, George Jevremović suggested that I expand the fourth chapter of *Material Culture* into this book, making it the first in the series co-published by Material Culture of Philadelphia and the Indiana University Press. John Gallman's able

staff at the Press made helpful suggestions, and I wish to thank John, Jane Lyle, Susan Barnett, Sharon Sklar, and Zig Zeigler. Kathy Foster and Karen Duffy read the text, catching infelicities. Michael Cavanagh and Kevin Montague printed my photographs and took most of the studio portraits of the pots that appear in color. Kathy Sitarski, Kristie Greenlaw, and John McGuigan got the back matter onto disks, and then, using the sketches I made of the pages, Bruce Carpenter composed the book, getting it into the computer, ready for the press.

My gratitude widens to my colleagues and students in my discipline, folklore, and it tightens and deepens among the members of my family. My grandfather, Carl Joseph Poch, master carpenter, first taught me the virtues of serious craft. My father, whose name I bear, nurtured my early interests in art and history. The family around me brings me constant joy: Judy and Bill, Isabella and Wally, and my children, Polly, Harry, Lydia, and Ellen Adair.

My greatest debt is to my love, Kathleen. Kathy and Ellen Adair came with me on most of the adventures that brought the information in this book. They welcomed me home from the others and made our house a place of love while I wrote and fussed over the design.

I dedicated my small book in Turkish on Turkish art to Ahmet Şahin, the greatest of Kütahya's twentieth-century masters. This one I dedicate to the current generation, my dear friends, the ceramic masters of modern Kütahya, but this book, like all of them, owes the most to Kathy.

NOTES

The Text

P. 17. This book, a revision of the fourth chapter of *Material Culture* (Bloomington: Indiana University Press, 1999), combines, updates, and extends two talks presented to the National Council on Education for the Ceramic Arts. The first, given in 1993, was published as "Values in Clay," *The Studio Potter* 22:2 (1994): 2–7. The second, given as the keynote address of the annual conference in 1998, was published as "In Praise of Heroes at Work in the Clay," *NCECA Journal* 19 (1998): 17–27.

Pp. 17–19. Compressed here, my concept of art is worked out most completely in these books: *The Spirit of Folk Art* (New York: Abrams and Museum of International Folk Art, 1989), *Turkish Traditional Art Today* (Bloomington: Indiana University Press, 1993), and *Art and Life in Bangladesh* (Bloomington: Indiana University Press, 1997). The best writers on art in our times, I believe, are Robert Plant Armstrong and Michael Baxandall. See Armstrong's trilogy *The Affecting Presence: An Essay in Humanistic Anthropology* (Urbana: University of Illinois Press, 1971), *Wellspring: On the Myth and Source of Culture* (Berkeley: University of California Press, 1975), and *The Powers of Presence: Consciousness, Myth, and Affecting Presence* (Philadelphia: University of Pennsylvania Press, 1981). Baxandall outlines his method in *Patterns of Intention: On the Historical Explanation of Pictures* (New Haven: Yale University Press, 1985), and he exemplifies it elegantly in *Painting and Experience in Fifteenth-Cen-*

tury Italy: A Primer in the Social History of Pictorial Style (New York: Oxford University Press, 1974) and *The Limewood Sculptors of Renaissance Germany* (New Haven: Yale University Press, 1985). For me, the best of writers on art remains William Morris. The key collections of his essays are: *Hopes and Fears for Art* (London: Ellis and White, 1882), *Signs of Change* (London: Reeves and Turner, 1888), and *Architecture, Industry, and Wealth: Collected Papers* (London: Longmans, Green, 1902).

P. 19. The information on Bangladesh briefly recapitulates the findings from my book *Art and Life in Bangladesh*. Statistics come from Mohammad Shah Jalal, *Traditional Pottery in Bangladesh* (Dhaka: International Voluntary Services, 1987), pp. 15–16, and the tables following p. 55.

P. 21. S. S. Biswas, *Terracotta Art of Bengal* (Atlantic Highlands: Humanities Press, 1982), pp. 113, 191, plate 58, illustrates two fragmentary tiles from the second or third centuries A.D., showing women carrying *kalshis* of the contemporary type in the way they are carried today.

P. 23. For Haripada Pal, see Glassie, *Art and Life in Bangladesh*, chapter 6.

P. 24. The aesthetic of the modern *murti* is continuous with that of the sculpture of Gupta, Pala, and Sena times as described by Stella Kramrisch in Barbara Stoler Miller, ed., *Exploring India's Sacred Art: Selected Writings of Stella Kramrisch* (Philadelphia: University of Pennsylvania Press, 1983), pp. 217–22; Joanna Gottfried Williams, *The Art of Gupta In-*

dia: Empire and Province (Princeton: Princeton University Press, 1982), pp. 61, 69–70; S. K. Saraswati, *A Survey of Indian Sculpture* (Calcutta: K. L. Mukhopadhyay, 1957), pp. 124–26; and A. K. M. Shamsul Alam, *Sculptural Art of Bangladesh: Pre-Muslim Period* (Dhaka: Department of Archaeology and Museums, 1985), pp. 66–67.

P. 24. The quality of ripe, fecund youthfulness found in Hindu art is found as well in the Yoruba art of West Africa; see: Armstrong, *Wellspring,* pp. 33–35; and Robert Farris Thompson, *Black Gods and Kings: Yoruba Art at UCLA* (Bloomington: Indiana University Press, 1978), chapter 8.

P. 26. Pratapaditya Pal, *Hindu Religion and Iconology: According to the Tantrasāra* (Los Angeles: Vichitra Press, 1981), pp. 58–67, suggests the variety of images of Kali. For Kali: David Kinsley, *Hindu Goddesses: Visions of the Divine Feminine in the Hindu Religious Tradition* (Berkeley: University of California Press, 1988), chapter 8; Ajit Mookerjee, *Kali: The Feminine Force* (Rochester: Destiny Books, 1988).

P. 30. In his *Introduction to Indian Art* (Madras: Theosophical Publishing House, 1923), pp. vii–viii, Ananda K. Coomaraswamy writes that in India no "unsurmountable" barriers divide fine from applied art or folk from canonical art, and that the idea of a "useless art" would be "regarded as a monstrous product of human vanity" by the artists of India.

P. 33. Louise Allison Cort noted the similarity of the vessel and the image in India in "The Role of the Potter in South Asia," in Michael W. Meister, ed., *Making Things in South Asia: The Role of the*

Artist and Craftsman (Philadelphia: University of Pennsylvania Department of South Asia Regional Studies, 1988), p. 167.

P. 34. Raus in the days before Lars Andersson is described by Otto von Friesen in *Krukan från Raus* (Stockholm: Nordiska Museet, 1976).

P. 36. The Meaders family has been excellently documented: Allen H. Eaton, *Handicrafts of the Southern Highlands* (New York: Russell Sage Foundation, 1937), pp. 212–14; Ralph Rinzler and Robert Sayers, *The Meaders Family: North Georgia Potters* (Washington: Smithsonian Institution Press, 1980); Nancy Sweezy, *Raised in Clay: The Southern Pottery Tradition* (Washington: Smithsonian Institution Press, 1984), pp. 98–111; John A. Burrison, *The Meaders Family of Mossy Creek: Eighty Years of North Georgia Folk Pottery* (Atlanta: Georgia State University Art Gallery, 1976); and John A. Burrison, *Brothers in Clay: The Story of Georgia Folk Pottery* (Athens: University of Georgia Press, 1983), chapters 6 and 16.

P. 39. The face jug: John Michael Vlach, *The Afro-American Tradition in Decorative Arts* (Cleveland: Cleveland Museum of Art, 1978), pp. 81–94; John Michael Vlach, "International Encounters at the Crossroads of Clay: European, Asian and African Influences on Edgefield Pottery," in Catherine Wilson Horne, ed., *Crossroads of Clay: The Southern Alkaline-Glazed Stoneware Tradition* (Columbia: McKissick Museum, 1990), pp. 27–36; Cinda K. Baldwin, *Great and Noble Jar: Traditional Stoneware of South Carolina* (Athens: University of Georgia Press, 1995), pp. 79–90; Burrison, *Brothers in Clay,* pp. 76, 229, 235, 269; Charles G. Zug, III, *Turners and*

Burners: Folk Potters of North Carolina (Chapel Hill: University of North Carolina Press, 1986), pp. 384–86; Charles G. Zug, III, *Burlon Craig: An Open Window into the Past* (Raleigh: North Carolina State University Foundations Gallery, 1994), pp. 6–21; and Steve Siporin, *American Folk Masters: The National Heritage Fellows* (New York: Abrams and Museum of International Folk Art, 1992), pp. 98–103. Today's explosion in the production of face jugs is documented in Robert C. Lock, *The Traditional Potters of Seagrove, North Carolina* (Greensboro: Antiques and Collectibles Press, 1994), pp. 184–90; and William W. Ivey, *North Carolina and Southern Folk Pottery: A Pictorial Survey* (Seagrove: Museum of North Carolina Pottery, 1992).

P. 39. See Cecelia Conway, *African Banjo Echoes in Appalachia: A Study of Folk Traditions* (Knoxville: University of Tennessee Press, 1995).

Pp. 41–42. For the Hewell family of Gillsville, Georgia, see these books by John A. Burrison: *Brothers in Clay*, chapter 15; *Georgia Clay: Pottery of the Folk Tradition* (Macon: Museum of Arts and Sciences, 1989), p.34; and *Handed On: Folk Crafts in Southern Life* (Atlanta: Atlanta History Center, 1993), pp. 20, 46–47.

P. 48. Acoma's tradition: Jonathan Batkin, *Pottery of the Pueblos of New Mexico: 1700–1940* (Colorado Springs: Taylor Museum, 1987), pp. 136–47, 154–56; Francis H. Harlow, *Two Hundred Years of Historic Pueblo Pottery: The Gallegos Collection* (Santa Fe: Morning Star Gallery, 1990), plates 15–30; Larry Frank and Francis H. Harlow, *Historic Pottery of the Pueblo Indi-* *ans: 1600–1880* (West Chester: Schiffer, 1990), pp. 121–35; Alfred E. Dittert, Jr. and Fred Plog, *Generations in Clay: Pueblo Pottery of the American Southwest* (Flagstaff: Northland Press, 1980), pp. 43–44, 77, 119; Stephen Trimble, *Talking with the Clay: The Art of Pueblo Pottery* (Santa Fe: School of American Research Press, 1987), pp. 73–80; and Rick Dillingham, *Fourteen Families in Pueblo Pottery* (Albuquerque: University of New Mexico Press, 1994), pp. 82–103. The great book remains Ruth L. Bunzel, *The Pueblo Potter: A Study of Creative Imagination in Primitive Art* (New York: Dover, 1972, pub. 1929), and the most complete book on Acoma is Rick Dillingham, with Melinda Elliott, *Acoma and Laguna Pottery* (Santa Fe: School of American Research Press, 1992). In *Acoma and Laguna*, Dillingham brings the story to the present, mentioning Wanda Aragon's interest in revival: pp. 185, 194, 200–201. On p. 182, he shows a jar by her mother, Frances Torivio, and on p. 84, he shows a jar by Wanda. Works by Lilly Salvador can be found in Jonathan L. Fairbanks, *Collecting American Decorative Arts and Sculpture: 1971–1991* (Boston: Museum of Fine Arts, 1991), pp. 27, 89; and Bill Mercer, *Singing the Clay: Pueblo Pottery of the Southwest, Yesterday and Today* (Cincinnati: Cincinnati Art Museum, 1995), p. 9. Lillian Peaster includes Frances Torivio, Lilly Salvador, and Wanda Aragon in *Pueblo Pottery Families* (Atglen: Schiffer, 1997), pp. 11–15. Robert Nichols has written a brief introduction to Wanda Aragon and her family in "Keeping Tradition Alive," *Focus/Santa Fe* (Oct.–Dec. 1995): 14–15.

P. 51. Lucy Lewis and her family: Susan Peterson, *Lucy M. Lewis: American Indian*

Potter (Tokyo: Kodansha, 1984); Susan Peterson, *Pottery by American Indian Women: The Legacy of Generations* (New York: Abbeville Press, 1998), pp. 74–83, 132–41; Dillingham, *Fourteen Families in Pueblo Pottery*, pp. 92–103; Frederick J. Dockstader, *A Tribute to Lucy M. Lewis: Acoma Potter* (Fullerton: Museum of North Orange County, 1975).

Pp. 53–55. The storyteller: Barbara A. Babcock and Guy and Doris Monthan, *The Pueblo Storyteller: Development of a Figurative Ceramic Tradition* (Tucson: University of Arizona Press, 1986); Mark Bahti, *Pueblo Stories and Storytellers* (Tucson: Treasure Chest Publications, 1988); Glassie, *Spirit of Folk Art*, pp. 44–49.

Pp. 56–57. The early work at Kütahya is described by Oktay Aslanapa in *Osmanlılar Devrinde Kütahya Çinileri* (Istanbul: Sanat Tarihi Enstitüsü, 1949). John Carswell describes the middle period in *Kütahya Tiles and Pottery from the Armenian Cathedral of St. James, Jerusalem*, 2 vols. (Oxford: Oxford University Press, 1972). Şebnem Akalın and Hülya Yılmaz Bilgi present a fine collection, ranging from the eighteenth century to the early twentieth, in *Delights of Kütahya: Kütahya Tiles and Pottery in the Suna and İnan Kıraç Collection* (Istanbul: Suna and İnan Kıraç Research Institute, 1997). Another collection, largely from the same period, is presented by John Carswell in "Kütahya Tiles and Ceramics," in Sevgi Gönül, ed., *Turkish Tiles and Ceramics* (Istanbul: Sadberk Hanım Museum, 1991), pp. 49–102. For the twentieth century: Faruk Şahin, "Kütahya Seramik Teknolojisi ve Çini Fırınları Hakkında Görüşler," *Sanat Tarihi Yıllığı* 9 (1982): 133–64; Rıfat Çini, *Kütahya in Turkish Tile Making* (Istanbul:

Uycan Yayınları, 1991); Yılmaz Uyar, ed., *Sıtkı Olçar: From Ceramic to Tile: A Master the Kiln Soul* (Istanbul: Promat A. Ş., 1995); and Glassie, *Turkish Traditional Art Today*, pp. 425–562, 856–72.

P. 60. See Yael Olenik, *The Armenian Pottery of Jerusalem* (Tel Aviv: Haaretz Museum, 1986).

P. 64. For the artists of modern Kütahya, see Glassie, *Turkish Traditional Art Today*, especially chapters 14–17. When that book was published, in 1993, Kerim Keçecigil was emerging as one of the city's masters. Later in the 1990s, İsmail Yiğit, who was born in Kütahya and trained in fine arts at Marmara University, proved himself capable of handsome reproductions of the *çini* of the classical period. In time, he will find, as the others have, a style of his own within the tradition.

P. 73. Today the great *çini* of the sixteenth century is generally attributed to İznik. In its own day, it was made in both İznik and Kütahya, and when we are faced with a particular piece, it is, with rare exceptions, impossible to know whether it was made in İznik or Kütahya. Long ago, in his *Victoria and Albert Museum Guide to the Collection of Tiles* (London: Board of Education, 1939), p. 19, Arthur Lane commented that Kütahya ware could not be distinguished from that of İznik until the eighteenth century. In the third chapter of his *Later Islamic Pottery: Persia, Syria, Egypt, Turkey* (London: Faber and Faber, 1957), Arthur Lane established the developmental scheme that still provides the basis for thinking about sixteenth-century *çini*. That great ware has received excellent descriptive study; see:

Tahsin Öz, *Turkish Ceramics* (Ankara: Turkish Press, Broadcasting and Tourist Department, 1957); Gönül Öney, *Türk Çini Sanatı* (Istanbul: Yapı ve Kredi Bankası, 1976); Walter B. Denny, *The Ceramics of the Mosque of Rüstem Pasha and the Environment of Change* (New York: Garland, 1977); Nurhan Atasoy and Julian Raby, *Iznik: The Pottery of Ottoman Turkey* (London: Thames and Hudson, Alexandria Press, 1989); and John Carswell, *Iznik Pottery* (London: British Museum Press, 1998).

P. 74. James Joyce, *Finnegans Wake* (New York: Viking, 1939), p. 115.

P. 76. On De Morgan, Mark Hamilton has written an enjoyable biography, *Rare Spirit: A Life of William De Morgan, 1839–1917* (London: Constable, 1997). A sampling of his eclectic ware can be found in Roger Pinkham, *Catalogue of Pottery by William De Morgan* (London: Victoria and Albert Museum, 1973).

P. 77. I take my stand with the artisans of Turkey. There are thinkers in consumer societies who wish to steal art from its creators, reducing the aesthetic to a matter of the beholder's taste, and defining art in terms of their own reactions, but I believe that art is defined by the gift made to materials by the creator in the instant of concentration, and that the observer's responsibility is not to react positively or negatively in line with a supposedly refined sensibility, but to work, learning to appreciate the artist's gift, however strange it might at first appear. Turks call that gift, that presence in things which defines them as art, *aşk*: passion, devotion, love. It is what Wassily Kandinsky called soul and inner necessity: *Concern-*

ing the Spiritual in Art (New York: George Wittenborn, 1955, pub. 1912), pp. 52, 70; and Wassily Kandinsky and Franz Marc, eds., *The Blaue Reiter Almanac* (New York: Viking Press, 1974, pub. 1912), p. 153. It is what Bernard Leach called sincerity: *A Potter's Book* (Levittown: Transatlantic Arts, 1973), pp. 17–18. It is what Daisetz T. Suzuki called sincerity and devotion: *Zen and Japanese Culture* (Princeton: Princeton University Press, 1970), p. 226. It is what Ananda Coomaraswamy called care and honesty: *The Transformation of Nature in Art* (Cambridge: Harvard University Press, 1935), p. 90.

P. 80. On the issue of representation in Islamic art: Titus Burckhardt, *Art of Islam: Language and Meaning* (Westerham: World of Islam Festival, 1976), chapter 3; Oleg Grabar, *The Formation of Islamic Art* (New Haven: Yale University Press, 1977), pp. 75–103; Thomas W. Arnold, *Painting in Islam: A Study of the Place of the Pictorial in Muslim Culture* (New York: Dover, 1965, pub. 1938), pp. 4–7; Glassie, *Turkish Traditional Art Today*, chapters 5, 23; Yusuf Al-Qaradawi, *The Lawful and the Prohibited in Islam* (Indianapolis: American Trust Publications, 1960), pp. 100–120.

P. 86. Mevlana Celaleddin Rumi's story begins in the second book at verse 1720 of the *Mesnevi.* A full translation of that vast work was prepared by Reynold A. Nicholson, *The Mathnawi of Jalalu'ddin Rumi,* 8 vols. (London: Luzac, 1925–1940). Nicholson included an abbreviated version of the story in *Tales of Mystic Meaning* (Oxford: Oneworld, 1995), pp. 95–97. I took it from Mevlana's *Mesnevi,* translated and edited by Veled İzbudak and Abdülbaki Gölpınarlı (Istanbul: Milli

Eğitim Bakınlığı Yayınlarlı, 1990), II, pp. 132–39.

P. 91. Examples of figurative ceramics from Japan: Richard S. Cleveland, *200 Years of Japanese Porcelain* (St. Louis: City Art Museum, 1970), pp. 55, 96–97; Hugo Munsterberg, *The Ceramic Art of Japan* (Rutland: Charles E. Tuttle, 1964), pp. 44, 96, 122, 155, 177, 221; Donald A. Wood, Teruhisa Tanaka, and Frank Chance, *Echizen: Eight Hundred Years of Japanese Stoneware* (Birmingham: Birmingham Museum of Art, 1994), pp. 70–71; Janet Barriskill, *Visiting the Mino Kilns, With a Translation of Arakawa Toyozo's "The Traditions and Techniques of Mino Pottery"* (Broadway: Wild Peony, 1995), pp. 28, 37, 121; Louise Allison Cort, *Seto and Mino Ceramics: Japanese Collections in the Freer Gallery of Art* (Washington: Smithsonian Institution, 1992), pp. 163–64; Louise Allison Cort, *Shigaraki, Potters' Valley* (Tokyo: Kodansha, 1979), pp. 266–67; and Tsugio Mikami, *The Art of Japanese Ceramics* (New York: Weatherhill, 1972), pp. 71, 124, 145, 174. In Mikami's book, the photograph on p. 124 shows a medieval stoneware lion from Seto in the seated form that continues to characterize work at Seto, in contrast to the pouncing form that has been characteristic of Hagi since the seventeenth century (see pp. 114–15).

P. 91. Figurative ceramics from China: He Li, *Chinese Ceramics: A New Comprehensive Survey from the Asian Art Museum of San Francisco* (New York: Rizzoli, 1996), pp. 9–10, 139, 272, 311, 331–32; Wanda Garnsey and Rewi Alley, *China: Ancient Kilns and Modern Ceramics, A Guide to the Potteries* (Canberra: Australian National University Press, 1983), pp. 106–32; Robert Tichane, *Ching-Te-Chen: Views of a Porcelain City* (Painted Post: New York State Institute for Glaze Research, 1983), pp. 35, 37, 74, 99; Hin-cheung Lovell, ed., *Jingdezhen Wares: The Yuan Evolution* (Hong Kong: Oriental Ceramic Society, 1984), pp. 26–27, 54–57, 90–93; P. J. Donnelly, *Blanc De Chine: The Porcelain of Téhua in Fukien* (London: Faber and Faber, 1969), pp. 8–41; and Fredrikke S. Scollard and Terese Tse Bartholomew, *Shiwan Ceramics: Beauty, Color, and Passion* (San Francisco: Chinese Culture Foundation, 1994). The white figures of Dehua were imitated in Korea as well as Japan; see W. B. Honey, *Corean Pottery* (New York: D. Van Nostrand, 1948), p. 16.

Pp. 91–92. For Mingei, see the introductory essays by Pearce and the Yanagis to Sori Yanagi, ed., *Mingei: Masterpieces of Japanese Folkcraft* (Tokyo: Kodansha, 1991); these good essays by Robert Moes: *Mingei: Japanese Folk Art from the Brooklyn Museum Collection* (New York: Universe, 1985), pp. 11–20, and *Mingei: Japanese Folk Art from the Montgomery Collection* (Alexandria: Art Services International, 1995), pp. 19–42, and "Edward Morse, Yanagi Soetsu and the Japanese Folk Art Movement," in Erica Hamilton Weeder, ed., *Japanese Folk Art: A Triumph of Simplicity* (New York: Japan Society, 1992), pp. 20–27; Yuko Kikuchi, "Hamada and the *Mingei* Movement," in Timothy Wilcox, ed., *Shoji Hamada: Master Potter* (London: Lund Humphries, 1998), pp. 22–25; Brian Moeran, *Lost Innocence: Folk Craft Potters of Onta, Japan* (Berkeley: University of California Press, 1984), pp. 12–27; and Richard L. Wilson, *Inside Japanese Ceramics: A Primer of Materials, Techniques, and Traditions* (New York: Weatherhill, 1995), pp. 32–34.

P. 92. Potters among the living national treasures: Masataka Ogawa and Tsune Sugimura, *The Enduring Crafts of Japan: 33 Living National Treasures* (New York: Walker/Weatherhill, 1968), pp. 5–42; Jan Fontein, ed., *Living National Treasures of Japan* (Boston: Museum of Fine Arts, 1983), pp. 16–18, 264–66.

P. 92. Kakiemon: Takeshi Nagatake, *Kakiemon* (Tokyo: Kodansha, 1981), pp. 6–12, 38–39; Kenji Adachi and Mitsuhiko Hasebe, *Japanese Painted Porcelain: Modern Masterpieces in Overglaze Enamel* (New York: Weatherhill, 1980), pp. 16–17, 233–34, plates 38–44, 84–85, 91, 162–64; Mikami, *Art of Japanese Ceramics*, pp. 164–65; Munsterberg, *Ceramic Art of Japan*, p. 141; Fontein, *Living National Treasures*, pp. 265–66.

P. 96. The missionary's report from Jingdezhen: Tichane, *Ching-Te-Chen*, pp. 57, 70, 73.

P. 96. Simeon Shaw comments on early divisions in labor in *History of the Staffordshire Potteries* (New York: Praeger, 1970, pub. 1829), pp. 104, 166.

P. 97. Richard L. Wilson, *The Art of Ogata Kenzan: Persona and Production in Japanese Ceramics* (New York: Weatherhill, 1991), pp. 115–16.

Pp. 100–101. A. L. Sadler wrote a full study of the tea ceremony in *Cha-no-yu: The Japanese Tea Ceremony* (Rutland: Charles E. Tuttle, 1963, pub. 1933). I think the best brief introduction is Soshitsu Sen XV, *Tea Life, Tea Mind* (New York: Weatherhill for the Urasenke Foundation, 1979). The relation of the tea ceremony to Zen is described by Suzuki, *Zen and Japanese Culture*, chapters 8–10; and by Hugo Munsterberg, *Zen and Oriental Art* (Rutland: Charles E. Tuttle, 1993), chapter 5. On the teabowl, tea utensils, and their aesthetics: Tadanari Mitsuoka, *Ceramic Art of Japan* (Tokyo: Japan Travel Bureau, 1949), pp. 170–72; Rand Castile, *The Way of Tea* (New York: Weatherhill, 1971), part 3; Ryoichi Fujioka, *Shino and Oribe Ceramics* (Tokyo: Kodansha, 1977), pp. 35–36, 157–61; Munsterberg, *Ceramic Art of Japan*, chapter 6. Seiroku Noma has written a magnificent general survey of Japanese art; the tea ceremony and its arts are treated in the fifth chapter of the second volume: *The Arts of Japan* (Tokyo: Kodansha, 1978). In his truly excellent introduction to Japanese pottery, Richard Wilson describes aesthetics effectively, treats the centers where tea ware is made, including Hagi, and illustrates the making of a Raku teabowl: *Inside Japanese Ceramics*, pp. 25–31, 41–45, 55–58, 164–76. A wonderful collection of Raku teabowls is assembled in the catalog *Chojiro: 400 Years Memorial Exhibition of Raku* (Kyoto: Raku Museum, 1988).

P. 102. Fawn-spot ware at Asahi: Mitoko Matsubayashi, *The Asahi Pottery in Uji* (Uji: Asahi Pottery, 1991), pp. 50, 56–61.

P. 107. Çanakkale pottery: Gönül Öney, *Türk Devri Çanakkale Seramikleri* (Ankara: Çanakkale Seramik Fabrikaları, 1971); Gönül Öney, "Çanakkale Ceramics," in Gönül, ed., *Turkish Tiles and Ceramics*, pp. 103–43; Ara Altun, *Çanakkale Ceramics: Suna and İnan Kıraç Collection* (Istanbul: Vehbi Koç Vakfı, 1996). Kınık pottery: Güngör Güner, *Anadolu'da Yaşamakta Olan İlkel Çömlekçilik* (Istanbul: Ak Yayınları, 1988), pp. 74–77; Glassie, *Turkish Traditional Art Today*, chapter 13.

P. 111. Reiko Chiba introduces the Seven Gods briefly in *The Seven Lucky Gods of Japan* (Rutland: Charles E. Tuttle, 1966). They are described as ceramic images in Hazel H. Gorham, *Japanese and Oriental Ceramics* (Rutland: Charles E. Tuttle, 1990), pp. 218–19.

P. 116. Here at the end, with pottery as the example, the folklorist offers an answer to this question: why does traditional art exist today? The direct answer is that it owes its existence to talented individuals with great personal integrity, brave people like Cheever Meaders, Frances Torivio, and Ahmet Şahin who so loved their art that they continued to practice it in times of slight hope, and wise people like Matthew Hewell, Wanda Aragon, and Nurten Şahin who gratefully received a tradition and reshaped it to suit themselves. Without devoted individuals, there is no art, but artists do not exist in isolation. They are aided or thwarted by forces in the environment. Americans, in whose country traditional art has been shoved to the margins by industrial capitalism, might argue that traditional art belongs to a backward, impoverished situation. Yet, traditional art flourishes in a poor country like Bangladesh, a prospering country like Turkey, and a rich country like Japan. If traditional art does not correlate with a level of wealth, what, then, are the features of its scene? One is a strong family within which — from Niroda Prasad Pal to Haripada Pal, from Chester Hewell to Matthew Hewell, from Frances Torivio to Wanda Aragon, from Zafer Şahin to Nurten Şahin, from Sadao Tatebayashi to Hirohisa Tatebayashi — an artistic tradition is transferred and invested with a sense of affection and duty. Another feature is a pattern of close, cooperative, combative interaction, a social arrangement among artists that sustains the individual through challenge and support. Best is a city full of solid ateliers, like Kütahya or Arita. A village of potters, like Kagajipara or Acoma or Kınık, provides a good setting, better than a dispersed rural landscape, but what matters is social connections among producers — situations like north Georgia, where Chester Hewell could learn from Lanier Meaders, or Kütahya, where Mehmet Gürsoy could learn from İhsan Erdeyer and Ahmet Şahin, or Hagi, where Norio Agawa could learn from the merchants who supplied his clay and glaze. To be art, an object must touch the whole person, holding a gift for the mind as well as the eye, and where traditional art is strongest, the artists have recourse to a philosophical system as well as a system of techniques and aesthetics. For some people that system is science, for others it is an academic tradition of critical discourse, but for most of the world's people, religion provides the philosophical matrix that enables depth in meaning and richness in interpretation. Traditional art fares best in alliance with religion — Haripada Pal's Hinduism, Mehmet Gürsoy's Islam, Norio Agawa's Buddhism, or Matthew Hewell's Christianity. A robust market is a blessing in the artist's context, but where religion has not been displaced, the market will be sufficient. If all that is true, and I believe it is, then traditional art is strong when personal integrity, family bonds, social exchange, and religious belief are strong. The reverse will also be true. Where traditional art fails, personal integrity is weak, families are broken, society is fragmented, and religion has lost its philosophical

value. The scene is one of disrupted confidence, alienation, and secular law, where, it is argued, wealth somehow balances the account.

P. 119. My friend Mark Hewitt points one clear route to the future. For his work see: Charles G. Zug, III, *Mark Hewitt: Stuck in the Mud* (Cullowhee: Western Carolina University Beck Gallery, 1992); Charles Millard, *Mark Hewitt: Potter* (Raleigh: North Carolina State University Visual Arts Center, 1997). Every morning I take my coffee from the breakfast table to my desk in a mug made by Mark.

The Photographs

P. 1. Alagar Chettiar at work, paddling the bottom of a pot he had thrown; Maravarpatti, Tamil Nadu, India, 1999. This and all other unattributed photographs are by the author.

P. 2. Norio Agawa at the wheel, Hagi, Japan, 1998.

P. 3. Slip-decorated earthenware from northwestern Anatolia, for sale in Edirne, Turkey, in 1984.

P. 7. İbrahim Erdeyer painted this plate after his return from military service in November 1984. I bought it from Muzaffer Kılıç at Selvi Ticaret in the Covered Bazaar, Istanbul, and then went in search of its maker. This plate, one of the masterpieces of modern Turkish ceramics, is of special significance to me. With it, I began my fieldwork in Kütahya and my deep friendship with its creator. The plate appears in color on the cover of my little book *Günümüzde Geleneksel Türk Sanatı* (Istanbul: Pan Yayıncılık, 1993). Painted

underglaze on a composite white body (an instance of *çini*), it is 42 cm. (about 16 ½ in.) in diameter.

P. 8. Matthew Hewell's ash-glazed stoneware jug, which he made in Gillsville, Georgia, in October 1993, is 8 ½ in. tall. Photograph by Michael Cavanagh and Kevin Montague.

P. 10. Slipped and slip-painted, this earthenware jar was made by Wanda Aragon, Acoma, New Mexico, in 1996. It is 5 ½ in. tall. Wanda's sister Lilly Salvador also paints a version of this design. Photograph by Michael Cavanagh and Kevin Montague.

P. 11. The ash-glazed stoneware face jug was made by Cleater J. Meaders, with help from his wife, Billie, near Cleveland, north of Mossy Creek in White County, Georgia, in 1999. It is 10 ¼ in. tall. Photograph by Michael Cavanagh and Kevin Montague.

P. 12. Rising from burned red earth to the thick white of the rice straw glaze, this stoneware vase, made by Norio Agawa, Hagi, Japan, in 1998, stands 11 ¼ in. tall. Intended to hold flowers during the tea ceremony, it echoes the form of a humble bucket and evokes the form of the *torii* gates of a Shinto shrine. Photograph by Michael Cavanagh and Kevin Montague.

P. 13. This porcelain bottle was created at Hirohisa Tatebayashi's kiln, Arita, Japan, in 1994. It was thrown by Chitoshi Matsuda, then glazed and fired by Hirohisa. Then Hirohisa drew Sadao Tatebayashi's design of Chinese boys playing crack the whip, Kikuyo Kudioka filled his drawing with overglaze enam-

els, and Hirohisa fired it again. It is 10 in. tall. Photograph by Michael Cavanagh and Kevin Montague.

P. 14. Jagadhatri, a form of Durga, is worshiped for one day, set by the phases of the moon in autumn. This *murti*, nearly life size, was shaped of clay on an armature of wood and straw and painted by Haripada Pal. Then it was positioned for *puja* in his workshop on Shankharibazar, Dhaka, Bangladesh. The statue existed only for the one day on which it was photographed, November 1, 1998.

P. 15. This detail of a clay "wall plate" in relief of Lord Krishna, by Haripada Pal, was photographed in process in 1995. It has since been painted and installed in the Shankharibazar Kali Mandir, Dhaka, Bangladesh.

P. 22. This painted clay *murti* of Kali stood for the six days of Shama Puja next to the Basudev Mandir, Tanti Bazar, Dhaka, Bangladesh, in 1998.

P. 27. Pictured below, Rakshakali was sculpted of clay and painted by Haripada Pal, then ornamented by the goldsmiths of Tanti Bazar. Life-size, it stands as the main image for worship in the Shankharibazar Kali Mandir, Dhaka, Bangladesh. The photos above show a similar *murti* of Kali by Haripada Pal, in process in his shop in January 1998.

P. 28. These painted clay *murtis* of Kali existed for the duration of Shama Puja, then both were sacrificed in the Buriganga on October 23, 1998.

P. 32. Babu Lal Pal's painted clay *murti* of Radha and Krishna, which he made

for his own devotion in Khamarpara, Shimulia, in 1995, appears in color on the dust jacket of *Art and Life in Bangladesh*. It is shown in its straw and completed forms in that book on p. 220.

P. 35. When I was in Sweden in 1993, I asked Lars Andersson to select one of his works for me to buy, and he chose this salt-glazed stoneware crock. Stamped Raus, it is 7½ in. tall.

P. 37. Made by Lanier Meaders, Mossy Creek, Georgia, in 1967, this ash-glazed stoneware pitcher is marked LM on the bottom. It stands 8½ in. tall.

P. 38. These ash-glazed stoneware face jugs illustrate the development of Lanier Meaders' style. The one at the top, with rocks for eyes and teeth, was made in 1967, when he had made few such jugs; it is 10 in. tall. The one in the middle to the left, from 1975, is 9¼ in. tall. The one at the bottom, concluding his search for realism, measures 9 in. tall. It came from the last kiln Lanier Meaders burned, in 1991.

P. 40. The ash-glazed stoneware face jug, made by Anita Meaders, Mossy Creek, Georgia, in 1991, is 7¼ in. tall.

P. 43. Chester Hewell, Gillsville, Georgia, made the ash-glazed stoneware face jug in 1993. The teeth are bits of busted china. Stamped CH on the handle, the jug is 10½ in. tall. When he signed and dated it on the bottom, Chester added the letters CSA.

P. 44. The ash-glazed stoneware face jug at the top is affixed to a fence at Chester Hewell's home in Gillsville, Georgia. The

face jug to the left is one of the first that Chester Hewell made; it was fired by Lanier Meaders. The man that Chester Hewell made before the ash-glazed stoneware Confederate officer pictured at the bottom, can be found in John Burrison's *Handed On*, p. 46. Matthew Hewell's Confederate woman, similar in size, stands 16 in. tall.

P. 50. *Above.* Creamy white, black, and three shades of orange-brown, this earthenware jar was made by Lilly Salvador, Acoma, New Mexico, in 1997. For it, she "renewed" the design of an Acoma pot of the 1850s that she saw at the Smithsonian Institution. *Below.* This earthenware jar in white, black, and two shades of orange-brown, was made by Wanda Aragon in 1987. She developed the design from a photograph she saw in a magazine of an Acoma pot from the end of the nineteenth century. Both of these jars are 6 ½ in. tall.

P. 55. Hand-built earthenware, like her vessels, painted in white, black, brown, and orange-brown, these storytellers were made by Frances Torivio, Acoma, New Mexico, in 1988. The larger one is 5 ¼ in. tall.

P. 61. This *çini* panel of tiles was painted by Ahmet Şahin, Kütahya, Turkey, in 1989, when he was eighty-two. The master took his inspiration from the tiles on the tomb of Mehmet I, the Yeşil Türbe in Bursa, that was completed in 1421. He added the border, changed the colors — the palette is black, dark blue, turquoise, yellow, red, and white — and he spread the design over six 20 by 20 cm. tiles (so the piece is about 16 in. wide). It is in the permanent collection of the Indiana Uni-

versity Art Museum, Bloomington, Indiana; photograph by Michael Cavanagh and Kevin Montague.

P. 65. Nurten Şahin painted this *çini* plate to a design by Ahmet Şahin, her husband's grandfather. Her signature interrupts the border at the top. Made in Kütahya, Turkey, in 1998, it is 31 cm. (12 ¼ in.) in diameter. Photograph by Michael Cavanagh and Kevin Montague.

P. 66. Painted by Kerim Keçecigil, Kütahya, Turkey, in 1994, this *çini* plate is encircled by a border that repeats the name of God: Allah, Allah, Allah. . . . Measuring 42 cm. (16 ⅝ in.) in diameter, it is in the permanent collection of the Indiana University Art Museum; photograph by Michael Cavanagh and Kevin Montague.

P. 69. This *çini* plate, painted by İbrahim Erdeyer, Kütahya Turkey, in 1994, measures 31 cm. (12 ¼ in.) in diameter. A gift of the artist, it is in the permanent collection of the Indiana University Art Museum; photograph by Michael Cavanagh and Kevin Montague.

P. 70. In its design, the *çini* plate in Mehmet Gürsoy's hands is a modern variation on the Turkish floral plates of the second half of the sixteenth century — their designs, in turn, deriving from Ming porcelain. In its form, the plate is a Turkish interpretation of an idea from Renaissance Italy. Exemplifying his brave new style of the later 1990s, the plate was designed by Mehmet and painted by his student Fidan Uçar, Kütahya, Turkey, in 1997. It is 31 ½ cm. (about 12 ½ in.) in diameter.

P. 71. Mehmet Gürsoy drew the form of this *sürahi* (a water jug) from late sixteenth-

century Turkish examples. He painted it with the lotus design, derived from early sixteenth-century *çini*, that brought him his first fame, and he added a bird to symbolize the artist's willing participation in the beauty of nature. Created in Kütahya, Turkey, in 1990, the piece is now in the permanent collection of the Museum of International Folk Art, Santa Fe, New Mexico; photograph by Blair Clark.

P. 72. In 1985, Ahmet Şahin, the great master of Kütahya, Turkey, painted this *çini* plate to an original design, inspired by the Turkish plates of the later sixteenth century. It measures 31 cm. (12 ¼ in.) in diameter, and it is in the permanent collection of the Museum of International Folk Art; photograph by Blair Clark.

P. 75. The upper plate to the right exhibits two features of Sıtkı Olçar's style. Its design is based on the earthenware of Çanakkale, Turkey, and the *çini* body is coated with a tinted glaze.

P. 79. *Above.* Carrying the larger of Nurten Şahin's two designs with the *Besmele*, this *çini* plate measures 35½ cm. (14 in.) in diameter. It employs the palette seen in the plate on p. 65. Created in Kütahya, Turkey, in 1993, it is now in the permanent collection of the Indiana University Art Museum. *Below.* Ahmet Şahin's *Besmele* of 1990 runs over three 20 by 20 cm. tiles; it is nearly two feet long. Framed for sale and hanging by Edip Çini in Kütahya, the piece is now in the permanent collection of the Museum of International Folk Art. Photographs by Michael Cavanagh and Kevin Montague.

P. 81. *Above.* In dark shades of blue, red, and green, this plate carries the design

of the interlocked star, associated by modern Turks with the Seljuks of thirteenth-century Konya, and seen most often in paneled wood on the doors of mosques. The design is centered on the plate, but the lack of a border and the foliated rim enhance the suggestion that this is a fragment of an infinite expanse. Painted by İbrahim Erdeyer, Kütahya, Turkey, in 1994, it measures 38 cm. (15 in.) in diameter. *Below.* Painted in dark blue, turquoise, red, and green on white by Ahmet Hürriyet Şahin, Kütahya, Turkey, in 1994, this is an original design. It is composed of five 20 by 20 cm. tiles, and four triangular tiles, and so measures two feet from side to side. Photographs by Michael Cavanagh and Kevin Montague.

P. 83. *Above.* This tile, notable for its material quality, was painted by Mehmet Gürsoy, Kütahya, Turkey, in 1993. It measures 24½ cm. (9½ in.) square. The same design painted on plates by Mehmet in 1991 and 1993 can be found in *Turkish Traditional Art Today*, pp. 511, 870; comparisons among them will reveal his development toward elaboration. *Below.* When Hakkı Ermumcu, a leader among Kütahya's artists in the 1970s, went blind, he gave his designs to İbrahim Erdeyer, and İbrahim used one of them to paint this plate as an homage to Hakkı in 1994. It is 31 cm. (12½ in.) in diameter. Both of these pieces are in the classical palette — black, blue, dark blue, turquoise, green, and red on white. Both were given by the artists to the permanent collection of the Indiana University Art Museum; photographs by Michael Cavanagh and Kevin Montague.

P. 84. *Above.* When he painted this plate in February 1993, Mehmet Gürsoy be-

lieved that it was his finest work to date, too fine to sell, so he gave it to the permanent collection of the Indiana University Art Museum. Based upon a *çini* plate from about 1575, it measures 42 cm. (16½ in.) in diameter. *Below.* The plate painted by Habib Bakılan, Kütahya, Turkey, in 1993, was also based on a particular historical piece, made about 1550. It measures 38 cm. (15 in.) in diameter. For the originals, see Atasoy and Raby, *Iznik*, nos. 240, 723. The masters of different ateliers today, Mehmet and Habib were partners when these plates were created. Then as now, they were not interested in making reproductions, but in using models from the past to create in the present. Both used the classical palette, changing the colors of the originals, Habib radically, and both added versions of a floral border that they had developed in 1990. Ultimately the idea of the floral border would prompt Mehmet Gürsoy to create new designs that blurred the distinction between field and border (see p. 70). Photographs by Michael Cavanagh and Kevin Montague.

P. 87. The *çini* plate painted in the classical palette by Fevziye Yeşildere in the atelier of Mehmet Gürsoy, Kütahya, Türkey, in 1994, measures 31 cm. (12¼ in.) in diameter.

P. 88. *Above.* Employing designs from her family tradition, Wanda Aragon, Acoma, New Mexico, made this parrot pot in 1998. Creamy white, black, and orange-brown, it is 5¼ in. tall. *Below.* The plate by Mehmet Gürsoy, Kütahya, Turkey, was painted in 1993, dominantly in shades of green. It is 31½ cm. (12½ in.) in diameter, and it is in the permanent collection of the Indiana University Art Museum; photograph by Michael Cavanagh and Kevin Montague.

P. 95. Produced at Hirohisa Tatebayashi's kiln, Arita, Japan, in 1994, this porcelain plate was drawn by Takasho Nakashima to a design by Hirohisa Tatebayashi, then painted by Kikuyo Kudioka. Green, blue, red, and pink on white, with a tan bird on a gray limb, in has a diameter of 12⅛ inches.

P. 103. Made by Kaneko Nobuhiko at the Johzan Kiln, Hagi, Japan, in 1998, this ash-glazed stoneware pot holds fresh water for the tea ceremony. It has the black lacquered top that is usual for the form, and it is 6 in. tall. In size, shape, and color, soft and small, the pot is designed, Kaneko said, to evoke a human baby and provoke an emotion of affection.

P. 104. *Top.* Kaneko Nobuhiko made this bone-lidded, stoneware tea canister, with the rice straw white glaze, at the Johzan Kiln, Hagi, Japan, in 1994. *Middle.* The ash-glazed stoneware teabowl, fired to achieve the firefly effect, was made in Hagi, in 1998, by Seichi Sakakura, the owner of a restaurant and a grocery store and a dedicated amateur potter. *Bottom.* Norio Agawa's magnificent stoneware teabowl, partially slipped and ash-glazed, came from his kiln in Hagi on May 30, 1998. All three of these works are 3¼ in. tall.

P. 106. Red, green, and black on white, this slipped and slip-decorated earthenware teapot was made in Kınık, Bilecik, Turkey, and bought in Bursa in 1990. It is 6¼ in. long.

P. 109. Takuo Matsumura, Hagi, Japan, used an old mold by his wife's uncle, the master Geirin Nakano, to make this ash-

137

glazed stoneware statue of Jurojin, one of the Seven Gods, in 1998. In the soft, subtle tones of Hagi *yaki*, it modulates upward from grayish pink to pale gray, and it stands 9¾ in. tall.

P. 110. These statues in process were photographed in Norio Agawa's shop, Hagi, Japan, in 1994 and 1998. Shoki is the demon queller, often imaged by the tilers who craft the demons for the roofs of temples. Daruma, famed for his dedication to meditation, is often portrayed by Japanese potters. He was painted on porcelain by Sadao Tatebayashi in Arita, and he is sculpted in the round by different artists in modern Kyoto. Hotei is the most frequently depicted of the Seven Gods. In the recent past in Hagi, Geirin Nakano sculpted Hotei in clay, and Susumu Kato has developed a superb stoneware image of Hotei in contemporary Seto.

P. 113. Fukurokuju, one of the Seven Gods, was shaped by Hachiro Higaki, Hagi, Japan, in 1996. Like other Japanese potters, Hachiro usually sculpts the god in a Chinese form, but in this rendition he strove to give him a new and particularly Japanese tone. Ash-glazed stoneware, employing both yellow and red clay, the statue is 18 in. tall.

P. 114. Slip-splashed and glazed with the rice straw white, this stoneware lion is 9¼ in. tall. It was begun in May and finished in June of 1998 by Norio Agawa in Hagi, Japan.

P. 117. Nurten Şahin, Kütahya, Turkey, painted this blue-and-white plate in 1993. Measuring 42 cm. (16½ in.) in diameter, it is now in the permanent collection of the Indiana University Art Museum.

P. 118. In 1998, Wanda Aragon, Acoma, New Mexico, used a late nineteenth-century Acoma design to paint the jar in her hands. Creamy white, black, and orange-brown, it is 7¼ in. tall. The face jug in Chester Hewell's hands, made in 1975, is pictured to the left on p. 44.

P. 120. The useful *kalshi*s were stacked on the kiln to produce decorative clouds on their sides in Norpara, Shimulia, Bangladesh, in 1996.

P. 121. The beautiful painted clay *murti* of Saraswati was positioned for worship at the Dhakeswari Mandir, Dhaka, Bangladesh, on February 3, 1987. Stored for a year, it was sacrificed at the beginning of the *puja* of 1988. The image for 1995 appears in *Art and Life in Bangladesh*, p. 161.

P. 122. Shaped of clay, painted white, black, and red, this image of Balarama, Krishna's brother, was made by Haripada Pal, Dhaka, Bangladesh, in 1995. It stands 11¾ in. tall.

BIBLIOGRAPHY

Adachi, Kenji, and Mitsuhiko Hasebe. *Japanese Painted Porcelain: Modern Masterpieces in Overglaze Enamel.* New York: Weatherhill, 1980.

Akalın, Şebnem, and Hülya Yılmaz Bilgi. *Delights of Kütahya: Kütahya Tiles and Pottery in the Suna and İnan Kıraç Collection.* Istanbul: Suna and İnan Kıraç Mediterranean Civilizations Research Institute, 1997.

Ali, Ahmed, trans. *Al-Qur'an.* Princeton: Princeton University Press, 1988.

Altun, Ara. *Çanakkale Ceramics: Suna and İnan Kıraç Collection.* Istanbul: Suna and İnan Kıraç Mediterranean Civilizations Research Institute, 1996.

Armstrong, Robert Plant. *The Affecting Presence: An Essay in Humanistic Anthropology.* Urbana: University of Illinois Press, 1971.

———. *Wellspring: On The Myth and Source of Culture.* Berkeley: University of California Press, 1975.

———. *The Powers of Presence: Consciousness, Myth, and Affecting Presence.* Philadelphia: University of Pennsylvania Press, 1981.

Artigas, J. Llorens, and José Corredor-Matheos. *Spanish Folk Ceramics.* Barcelona: Editorial Blume, 1974.

Atasoy, Nurhan, and Julian Raby. *Iznik: The Pottery of Ottoman Turkey.* London: Alexandria Press, Thames and Hudson, 1989.

Babcock, Barbara A., and Guy and Doris Monthan. *The Pueblo Storyteller: Development of a Figurative Ceramic Tradition.* Tucson: University of Arizona Press, 1986.

Baldwin, Cinda K. *Great and Noble Jar: Traditional Stoneware of South Carolina.* Athens: University of Georgia Press, 1995.

Barber, Edwin Atlee. *Tulip Ware of the Pennsylvania-German Potters: An Historical Sketch of the Art of Slip-Decoration in the United States.* Philadelphia: Pennsylvania Museum and School of Industrial Art, 1926 [1903].

Barriskill, Janet. *Visiting the Mino Kilns: With a Translation of Arakawa Toyozo's "The Traditions and Techniques of Mino Pottery."* Broadway: Wild Peony, 1995.

Baxandall, Michael. *Patterns of Intention: On the Historical Explanation of Pictures.* New Haven: Yale University Press, 1985.

Bivins, John, Jr. *The Moravian Potters in North Carolina.* Chapel Hill: University of North Carolina Press for Old Salem, 1972.

Blurton, T. Richard. *Hindu Art.* Cambridge: Harvard University Press, 1993.

Boas, Franz. *Primitive Art.* New York: Dover, 1955 [1927].

Brears, Peter C. D. *The English Country Pottery: Its History and Techniques.* Newton Abbot: David and Charles, 1971.

Brend, Barbara. *Islamic Art.* Cambridge: Harvard University Press, 1991.

Bunzel, Ruth L. *The Pueblo Potter: A Study of Creative Imagination in Primitive Art.* New York: Dover, 1972 [1929].

Burckhardt, Titus. *Art of Islam: Language and Meaning.* Westerham: World of Islam Festival, 1976.

Burrison, John A. *Brothers in Clay: The Story of Georgia Folk Pottery.* Athens: University of Georgia Press, 1983.

Cardew, Michael. *Pioneer Pottery.* New York: St. Martin's Press, 1969.

Carswell, John. *Blue and White: Chinese Porcelain and Its Impact on the Western World.* Chicago: David and Alfred Smart Gallery, 1985.

———. *Iznik Pottery.* London: British Museum Press, 1998.

Chaudhuri, Nirad C. *Hinduism: A Religion to Live By.* New York: Oxford University Press, 1979.

Çini, Rıfat. *Kütahya in Turkish Tilemaking.* Trans. Solmaz and Aydın Turunç. Istanbul: Uycan Yayınları, 1991.

Clark, Garth, Robert A. Ellison, Jr., and Eugene Hecht. *The Mad Potter of Biloxi: The Art and Life of George E. Ohr.* New York: Abbeville, 1989.

Coomaraswamy, Ananda K. *The Transformation of Nature in Art.* Cambridge: Harvard University Press, 1935.

———. *Christian and Oriental Philosophy of Art.* New York: Dover, 1956 [1943].

Cort, Louise Allison. *Shigaraki, Potters' Valley.* Tokyo: Kodansha, 1979.

———. *Seto and Mino Ceramics: Japanese Collections in the Freer Gallery of Art.* Washington: Freer Gallery of Art, Smithsonian Institution, 1992.

Crawford, Jean. *Jugtown Pottery: History and Design.* Winston-Salem: John F. Blair, 1964.

Deetz, James. *In Small Things Forgotten: An Archaeology of Early American Life.* New York: Anchor Books, 1996 [1977].

DeNatale, Douglas, Jane Przybysz, and Jill R. Severn, eds. *New Ways for Old Jugs: Tradition and Innovation at the Jugtown Pottery.* Columbia: McKissick Museum, 1994.

Denny, Walter B. *The Ceramics of the Mosque of Rüstem Pasha and the Environment of Change.* New York: Garland, 1977.

Dillingham, Rick. *Fourteen Families in Pueblo Pottery.* Albuquerque: University of New Mexico Press, 1994.

Dillingham, Rick, and Melinda Elliott. *Acoma and Laguna Pottery.* Santa Fe: School of American Research Press, 1992.

Domanovszky, György. *Hungarian Pottery.* Trans. Istvan Farkas. Budapest: Corvina, 1968.

Donnelly, P. J. *Blanc De Chine: The Porcelain of Téhua in Fukien.* London: Faber and Faber, 1969.

Dutt, Gurusaday. *Folk Arts and Crafts of Bengal: The Collected Papers.* Calcutta: Seagull, 1990.

Eck, Diana L. *Darśan: Seeing the Divine Image in India.* Chambersburg: Anima Books, 1985.

Eco, Umberto. *Art and Beauty in the Middle Ages.* Trans. Hugh Bredin. New Haven: Yale University Press, 1986 [1959].

Espejel, Carlos. *Mexican Folk Ceramics.* Barcelona: Editorial Blume, 1975.

Fischer, Eberhard, and Haku Shah. *Rural Craftsmen and Their Work.* Ahmedabad: National Insitute of Design, 1970.

Fontana, Bernard L., William J. Robinson, Charles W. Cormack, and Ernest J. Leavitt, Jr. *Papago Indian Pottery.* Seattle: University of Washington Press, 1962.

Frasché, Dean F. *Southeast Asian Ceramics: Ninth Through Seventeenth Centuries*. New York: Asia Society, 1976.

Fujioka, Ryoichi. *Shino and Oribe Ceramics*. Trans. Samuel Crowell Morse. Tokyo: Kodansha, 1977.

Glassie, Henry. *Pattern in the Material Folk Culture of the Eastern United States*. Philadelphia: University of Pennsylvania Press, 1969.

———. *Folk Housing in Middle Virginia: A Structural Analysis of Historic Artifacts*. Knoxville: University of Tennessee Press, 1975.

———. *The Spirit of Folk Art*. New York: Abrams and Museum of International Folk Art, 1989.

———. *Turkish Traditional Art Today*. Bloomington: Indiana University Press, 1993.

———. *Art and Life in Bangladesh*. Bloomington: Indiana University Press, 1997.

———. *Material Culture*. Bloomington: Indiana University Press, 1999.

Graburn, Nelson H. H., ed. *Ethnic and Tourist Arts: Cultural Expressions of the Fourth World*. Berkeley: University of California Press, 1979.

Greer, Georgeanna H. *American Stonewares, The Art and Craft of Utilitarian Potters*. Exton: Schiffer, 1981.

Griffing, Robert P., Jr. *The Art of the Korean Potter: Silla, Koryo, Yi*. New York: Asia Society, 1968.

Hansen, H. J., ed. *European Folk Art*. New York: McGraw-Hill, 1967.

Hedgecoe, John, and Salma Samar Damluji. *Zillij: The Art of Moroccan Ceramics*. Reading: Garnet, 1992.

Hillier, Bevis. *Master Potters of the Industrial Revolution: The Turners of Lane End*. London: Cory, Adams, and Mackay, 1965.

———. *Pottery and Porcelain: 1700–1914: England, Europe and North America*. New York: Meredith Press, 1968.

Hofer, Tamás, and Edit Fél. *Hungarian Folk Art*. Oxford: Oxford University Press, 1979.

Ioannou, Noris. *Ceramics in South Australia, 1836–1986: From Folk to Studio Pottery*. Netley: Wakefield Press, 1986.

Jenyns, Soame. *Ming Pottery and Porcelain*. London: Faber and Faber, 1988 [1953].

Jones, Michael Owen. *Craftsman of the Cumberlands: Tradition and Creativity*. Lexington: University Press of Kentucky, 1989 [1975].

Kandinsky, Wassily. *Concerning the Spiritual in Art*. New York: George Wittenborn, 1964 [1912].

Kandinsky, Wassily, and Franz Marc, eds. *The Blaue Reiter Almanac*. New York: Viking Press, 1974 [1912].

Kaufmann, Gerhard. *North German Folk Pottery*. Richmond: International Exhibitions Foundation, 1979.

Kerr, Rose. *Chinese Ceramics: Porcelain of the Qing Dynasty, 1644–1911*. London: Victoria and Albert Museum, 1986.

Kingery, W. David, and Pamela B. Vandiver. *Ceramic Masterpieces: Art, Structure, and Technology*. New York: Free Press, 1986.

Klein, Barbro, and Mats Widbom, eds. *Swedish Folk Art: All Tradition Is Change*. New York: Abrams, 1994.

Koverman, Jill Beute, ed. *I Made This Jar: The Life and Works of the Enslaved*

African-American Potter Dave. Columbia: McKissick Museum, 1998.

Kramer, Barbara. *Nampeyo and Her Pottery*. Albuquerque: University of New Mexico Press, 1996.

Kramer Carol. *Pottery in Rajasthan: Ethnoarchaeology in Two Indian Cities*. Washington: Smithsonian Institution Press,1997.

Kramrisch, Stella. *Unknown India: Ritual Art in Tribe and Village*. Philadelphia: Philadelphia Museum of Art, 1968.

Krishna, Nanditha. *Arts and Crafts of Tamilnadu*. Ahmedabad: Mapin, 1992.

Lane, Arthur. *Later Islamic Pottery: Persia, Syria, Egypt, Turkey*. London: Faber and Faber, 1957.

Laub, Lindsey King, and John A. Burrison. *Evolution of a Potter: Conversations with Bill Gordy*. Cartersville: Bartow History Center, 1992.

Leach, Bernard. *A Potter's Book*. Levittown: Transatlantic Arts, 1973.

———. *Hamada: Potter*. Tokyo: Kodansha, 1990 [1975].

Le Corbusier. *Journey to the East*. Trans. and ed. Ivan Zaknić. Cambridge: The MIT Press, 1989 [1966].

Le Free, Betty. *Santa Clara Pottery Today*. Albuquerque: University of New Mexico Press, 1976.

Lévi-Strauss, Claude. *The Way of the Masks*. Trans. Sylvia Modelski. Seattle: University of Washington Press, 1982.

Lewis, J. M. *The Ewenny Potteries*. Cardiff: National Museum of Wales, 1982.

Li, He. *Chinese Ceramics: A New Comprehensive Survey from the Asian Art Museum of San Fancisco*. New York: Rizzoli, 1996.

Lipski, Louis L., and Michael Archer. *Dated English Delftware: Tin-glazed Earthenware, 1600–1800*. London: Sotheby Publications, 1984.

Mahmud, Firoz. *Prospects of Material Folk Culture Studies and Folklife Museums in Bangladesh*. Dhaka: Bangla Academy, 1993.

Marriott, Alice. *Maria: The Potter of San Ildefonso*. Norman: University of Oklahoma Press, 1948.

Michell, George. *The Hindu Temple: An Introduction to Its Meaning and Forms*. Chicago: University of Chicago Press, 1988 [1977].

Mikami, Tsugio. *The Art of Japanese Ceramics*. New York: Weatherhill, 1972.

Millard, Charles. *Mark Hewitt: Potter*. Raleigh: North Carolina State University Visual Arts Center, 1997.

Moeran, Brian. *Lost Innocence: Folk Craft Potters of Onta, Japan*. Berkeley: University of California Press, 1984.

Moes, Robert. *Mingei: Japanese Folk Art from the Montgomery Collection*. Alexandria: Art Services International, 1995.

Morris, William. *Hopes and Fears for Art*. London: Ellis and White, 1882.

———. *Signs of Change*. London: Reeves and Turner, 1888.

———. *Architecture, Industry and Wealth: Collected Papers*. London: Longmans, Green, 1902.

Munsterberg, Hugo. *The Folk Arts of Japan*. Rutland: Charles E. Tuttle, 1958.

———. *The Ceramic Art of Japan: A Handbook for Collectors*. Rutland: Charles E. Tuttle, 1964.

Muraoka, Kageo, and Kichiemon Okamura. *Folk Arts and Crafts of Japan*. Trans. Daphne D. Stegmaier. New York: Weatherhill, 1973.

Musial, Jan, Clara Lee Tanner, and Russell P. Hartman. *Navajo Pottery: Traditions and Innovations.* Flagstaff: Northland Press, 1987.

Nagatake, Takeshi. *Kakiemon.* Tokyo: Kodansha, 1981.

Nahohai, Milford, and Elissa Phelps. *Dialogues with Zuni Potters.* Zuni: Zuni A:shiwi Publishing Company, 1995.

Noma, Seiroku. *The Arts of Japan.* Trans. John Rosenfeld. 2 vols. Tokyo: Kodansha, 1978.

Olenik, Yael. *The Armenian Pottery of Jerusalem.* Tel Aviv: Haaretz Museum, 1986.

Parks, Walter P. *The Miracle of Mata Ortiz: Juan Quezada and the Potters of Northern Chihuahua.* Riverside: Coulter Press, 1993.

Peterson, Susan. *Shoji Hamada: A Potter's Way and Work.* Tokyo: Kodansha, 1974.

———. *Lucy M. Lewis: American Indian Potter.* Tokyo: Kodansha, 1984.

———. *Pottery by American Indian Women: The Legacy of Generations.* New York: Abbeville, 1997.

Petsopoulos, Yanni, ed. *Tulips, Arabesques and Turbans: Decorative Art from the Ottoman Empire.* New York: Abbeville Press, 1982.

Philip, Leila. *The Road Through Miyama.* New York: Vintage Books, 1991.

Posey, Sarah. *Yemeni Pottery: The Littlewood Collection.* London: British Museum Press, 1994.

Pugh, P. D. Gordon. *Staffordshire Portrait Figures and Allied Subjects of the Victorian Era.* Woodbridge: Antique Collectors' Club, 1987 [1970].

Radhakrishnan, S., ed. *The Bhagavadgita.* New Delhi: HarperCollins, 1993 [1948].

Rasmussen, Tom, and Nigel Spivey, eds. *Looking at Greek Vases.* Cambridge: Cambridge University Press, 1991.

Reina, Ruben E., and Robert M. Hill, III. *The Traditional Pottery of Guatemala.* Austin: University of Texas Press, 1978.

Rhead, G. Wooliscroft, and Frederick Alfred Rhead. *Staffordshire Pots and Potters.* New York: Dodd, Mead, 1907.

Rice, A.H., and John Baer Stoudt. *The Shenandoah Pottery.* Strasburg: Shenandoah Publishing House, 1929.

Rinzler, Ralph, and Robert Sayers. *The Meaders Family: North Georgia Potters.* Washington: Smithsonian Institution Press, 1980.

Rodee, Marian, and James Ostler. *Zuni Pottery.* West Chester: Schiffer, 1986.

Safadi, Yasin Hamid. *Islamic Calligraphy.* London: Thames and Hudson, 1978.

Sato, Masahiko. *Chinese Ceramics: A Short History.* New York: Weatherhill/Heibonsha, 1981.

Sayers, Robert, and Ralph Rinzler. *The Korean Onggi Potter.* Washington: Smithsonian Institution Press, 1987.

Schimmel, Annemarie. *Mystical Dimensions of Islam.* Chapel Hill: University of North Carolina Press, 1975.

———. *Calligraphy and Islamic Culture.* New York: New York University Press, 1984.

Schlanger, Jeff, and Toshiko Takaezu. *Maija Grotell: Works Which Grow From Belief.* Goffstown: Studio Potter Books, 1996.

Scollard, Fredrikke S., and Terese Tse Bartholomew. *Shiwan Ceramics:*

Beauty, Color, and Passion. Trans. Li He. San Francisco: Chinese Culture Center, 1994.

Sen, Prabhas. *Crafts of West Bengal.* Ahmedabad: Mapin, 1994.

Shah, Haku. *Votive Terracottas of Gujarat.* New York: Mapin International, 1985.

Shaw Simeon. *History of the Staffordshire Potteries.* New York: Praeger, 1970 [1829].

Shearer, Allistair. *The Hindu Vision: Forms of the Formless.* London: Thames and Hudson, 1993.

Solon, L.M. *The Art of the Old English Potter.* New York: John Francis, 1906.

Spargo, John. *Early American Pottery and China.* Garden City: Garden City Publishing, 1946 [1926].

Suzuki, Daisetz T. *Zen and Japanese Culture.* Princeton: Princeton University Press, 1970.

Sweezy, Nancy. *Raised in Clay: The Southern Pottery Tradition.* Washington: Smithsonian Institution Press, 1984.

Tichane, Robert. *Ching-Te-Chen: Views of a Porcelain City.* Painted Post: New York State Institute for Glaze Research, 1983.

Trimble, Stephen. *Talking with the Clay: The Art of Pueblo Pottery.* Santa Fe: School of American Research Press, 1987.

Vlach, John Michael. *The Afro-American Tradition in Decorative Arts.* Cleveland: Cleveland Museum of Art, 1978.

Watson, Burton, trans. *The Lotus Sutra.* New York: Columbia University Press, 1993.

Whitaker, Irwin and Emily. *A Potter's Mexico.* Albuquerque: University of New Mexico Press, 1978.

Whybrow, Marion. *The Leach Legacy: The St. Ives Pottery and its Influence.* Bristol: Sansom, 1996.

Willett, E. Henry, and Joey Brackner. *Traditional Pottery of Alabama.* Montgomery: Museum of Fine Arts, 1983.

Wilson, Richard L. *The Art of Ogata Kenzan: Persona and Production in Japanese Ceramics.* New York: Weatherhill, 1991.

———. *Inside Japanese Ceramics: A Primer of Materials, Techniques, and Traditions.* New York: Weatherhill, 1995.

Wood, Donald A., Teruhisa Tanaka, and Frank Chance. *Echizen: Eight Hundred Years of Japanese Stoneware.* Birmingham: Museum of Art, 1994.

Wulff, Hans E. *The Traditional Crafts of Persia: Their Development, Technology, and Influence on Eastern and Western Civilizations.* Cambridge: The MIT Press, 1966.

Yanagi, Soetsu. *The Unknown Craftsman: A Japanese Insight into Beauty.* Ed. Bernard Leach. Tokyo: Kodansha, 1989 [1972].

Yanagi, Sori, ed. *Mingei: Masterpieces of Japanese Folkcraft.* Tokyo: Kodansha, 1991.

Yoshida, Mitsukuni. *In Search of Persian Pottery.* New York: Weatherhill/Tanosha, 1972.

Zug, Charles G., III. *Turners and Burners: The Folk Potters of North Carolina.* Chapel Hill: University of North Carolina Press, 1986.

———. *Mark Hewitt: Stuck in the Mud.* Cullowhee: Western Carolina University Beck Gallery, 1992.

INDEX

A

Acoma, 10, 48–56, 60, 73, 87–90, 118–119
aesthetics, 17, 24, 26, 29–30, 33–34, 42,
 47, 76–77, 85–86, 101, 105
Africa, 24
African Americans, 39, 47
Agawa, Motoko, 98, 100
Agawa, Norio, 2, 12, 98–102, 104–5, 108,
 110–12, 114–16, 119
Aguilar, Irene, 119
alpana, 31
Amish, 47
Anderberg, Hugo, 34, 36
Andersson, Lars, 34–36, 39, 93, 119
Appalachian region, 39, 47
Aragon, Delores J., 52
Aragon, Marvis, 48–49, 51–52, 87
Aragon, Wanda, 10, 48–54, 87–90, 93,
 118–19
Arita, 13, 91–98, 100, 107, 119
Armenians, 60
art, 17–19, 29–30, 33–34, 36, 39, 51, 54,
 56, 60, 63, 76–89, 94, 96–97, 116, 119
art history, 18–19
Asahi, 102
atelier, 56–60, 73, 96–98
Atlanta, 36
Auman, Dorothy, 119

B

Bakılan, Habib, 84
Bangladesh, 14–16, 19–34, 48, 54, 56, 88,
 91, 102, 108, 111, 115, 119–22
baseball, 116
Baydemir, Mustafa, 106–7
Benten, 111
Besmele, 78–79
Bible, 47
Bilecik, 106–7

bird as image, 50, 65, 71, 88, 90, 92, 95
Bishamon, 111
Bishwakarma, 23
Bizen, 91
Boston, 48
Buddha, 111
Buddhism, 82, 91, 101, 107–16
Bursa, 77

C

calligraphy, 66, 78–80, 82, 94, 108
Çanakkale, 76, 107
Cardew, Michael, 119
China, 57, 91–92, 108, 112
Christianity, 47, 80, 82
Cincinnati, 48
çini, 7, 56–90, 107, 117
Çinicioğlu, Hakkı, 60, 63
clay, 17, 19, 21, 23, 29, 48, 58, 101–2
Cochiti, 53
commerce, 21, 31, 52–54
comparison, 18–19
concentration, 17–18, 23, 45, 77
Confederacy, 44–45
Cordero, Helen, 53
craft, 18, 30, 94
Craig, Burlon, 39

D

Daikoku, 111
darshan, 29
Daruma, 110, 112
decoration, 30–31, 36, 47, 52, 56, 105,
 107
Dehua, 91
De Morgan, William, 76
Devi, 23
Dhaka, 14–15, 20, 22, 27–28, 108, 111,
 119, 121
Dhamrai, 20, 25

division in labor, 96
Durga, 23, 29, 33

E

earthenware, 10, 48–56, 88, 106–7, 118
Ebisu, 111
Echizen, 91
Emin, Mehmet, 60
England, 96, 101, 119
Erdeyer, Ayşe, 68
Erdeyer, Gizem, 68
Erdeyer, Gözde, 68
Erdeyer, İbrahim, 7, 64, 68–69, 72–76,
 81, 83, 87, 89–90, 96–97, 116
Erdeyer, İhsan, 57–59, 73, 76, 96, 98
Ermumcu, Hakkı, 64

F

face jug, 11, 38–44, 47, 54, 118
flower as image, 31, 69–72, 80, 82–85,
 88, 90, 92
folk art, 24, 36
Fukurokuju, 111–13

G

Ganesh, 23
Garcia, Dolores Lewis, 51
gender, 21, 52, 73
geometric design, 50, 61, 66, 69, 80–82,
 85, 117
Georgia, 8–9, 11, 36–47, 51, 54, 56, 118–
 19
Germany, 86
Ghora Pir, 33
Gillsville, 8–9, 41–47, 118–19
Girard, Alexander, 53
glaze, 34, 36, 58, 96, 102–5
Gürsoy, Mehmet, 64, 70–74, 76–77, 82–
 85, 87–90, 92, 97, 116

H

Hagi, 2, 12, 91, 98–105, 107–16, 119

Hamada, Shoji, 91
Hashimoto River, 98
Hewell, Chester, 41–45, 118–19
Hewell, Eli Davenport, 45
Hewell, Grace Nell, 42
Hewell, Harold, 42, 45
Hewell, Maryland (Bud), 45
Hewell, Matthew, 8, 42, 45–47, 93
Hewell, Nathaniel, 42, 45
Hewell's Pottery, 8–9, 39, 41–47
Hewitt, Mark, 119
Higaki, Hachiro, 98–99, 112–13
Hinduism, 19, 21–34, 82, 85–86, 111
Hotei, 110–12

I

identity, 45, 47
Imari, 92
India, 1, 108
Indiana, 55
Indiana University Art Museum, 79
Iran, 19, 76–77
Islam, 19, 31, 33, 77–86, 90, 107–8
Istanbul, 78
İznik, 73, 77
İznik Çini, 73

J

Jagadhatri, 14
Japan, 2, 12–13, 19, 58, 76, 91–105, 107–
 16, 119
Jerusalem, 60
Jingdezhen, 91, 96
Johnsson, Ludwig, 34
Joyce, James, 74
Judaism, 82
Jurojin, 109, 111

K

Kagajipara, 16, 20, 25
Kakiemon, 92, 94
Kali, 22–23, 26–28
kalshi, 16, 19–21, 29–34, 56, 120

Kannon, 91, 111
Karahisari, Ahmet, 82
Kartik, 23
Kasen Toen, 97
Kato, Hiroshige, 97
Kawai, Kanjiro, 91
Keçecigil, Kerim, 66, 74–76
Khamarpara, 32
kiln, 9, 21, 30, 36, 42, 51, 58, 60, 63, 90, 94, 96, 102, 120
Kınık, 106–7
Konya, 77, 82, 86
Koran, 31, 78–80, 90
Korea, 91, 98, 100
Krishna, 15, 23, 32
Kütahya, 56–91, 93–94, 96–98, 100, 107–8, 116–17
Kutani, 91
Kyoto, 91, 97, 102

L

Lakshmi, 23
Latin America, 24
Lewis, Andrew, 51
Lewis, Lucy, 51
Linga, 23
lion as image, 33, 112, 114–15
Longstreet, James, 45

M

Manasa, 23
master, 97–98
Matsuda, Chitoshi, 96
Matsumura, Takuo, 108–9
Meaders, Anita, 39–41
Meaders, Betty Jean, 41
Meaders, Billie, 36
Meaders, Cheever, 36, 41
Meaders, Cleater J. (C.J.), 11, 36, 39, 41
Meaders, Cleater J., III (Clete), 36
Meaders, David, 36, 39–41
Meaders, Edwin, 36, 41

Meaders, John Milton, 36
Meaders, Lanier, 36–39, 41–42
Meaders, Reggie, 36, 41
Mennonites, 47
Mexico, 119
Mingei, 91–92, 119
Mino, 91
Mitchell, Emma Lewis, 51
molds, 108
Mori clan, 100
Morocco, 77
Morris, William, 76, 91
Mossy Creek, 36–42
murti, 14, 19, 21–34, 54, 108, 121
Museum of International Folk Art, 79, 89
myth, 26

N

Nabeshima, 92
Nakano, Geirin, 108, 112
Nakış Çini, 59
Nara, 108
Native Americans, 39, 47–55, 87–90, 111
New Mexico, 10, 48–56, 87–90, 118–19
Nobuhiko, Kaneko, 101, 103–4, 119
North Carolina, 119

O

Oaxaca, 119
Ogata, Kenzan, 97
Olçar, Sıtkı, 75–76
Olympics, 36
Oruç, Mustafa, 59
Ottoman Empire, 77

P

painting, 31, 48, 52, 56, 63, 74, 77, 89–90, 92, 94, 96, 100
Paisano, Ruth, 51
Pal, Babu Lal, 32
Pal, Basanta Kumar, 25
Pal, Gauranga Chandra, 20

Pal, Haripada, 14–15, 23–24, 26–28, 31, 85, 93, 111, 119, 122
Pal, Malati Rani, 16
Pal, Niroda Prasad, 24
Pal, Parul Rani, 20
Pal, Sumanta, 24–25
Parvati, 23
Paul, Maran Chand, 108
Pollock, Jackson, 107
porcelain, 13, 57, 91–98
prayer, 21, 23–24, 26, 29, 48, 54, 78–79, 90
puja, 22, 28–29, 121

R

Radha, 23, 32
Rakshakali, 26–27
Raku, 58, 102, 111
Raus, 34–36, 93, 100, 119
Rayer Bazar, 20
region, 45, 51, 53, 77
representation, 39, 41, 53–54, 80, 90, 112
revitalization, 34, 52, 54, 56, 74, 77–78, 91–92
revival, 52, 56, 91–92
Rumi, Mevlana Celaleddin, 86

S

Şahin, Ahmet, 60–64, 72–74, 76, 78–79, 92, 97–98, 116
Şahin, Ahmet Hürriyet, 64–65, 76, 78, 81
Şahin, Faruk, 64
Şahin, Nurten, 64–65, 73–74, 76, 78–79, 93, 100, 116–17, 119
Şahin, Zafer, 64, 76
Saka, Shinbei, 108, 112
Sakakura, Seichi, 104–5
Salvador, Lilly, 48–51, 54–55, 89–90
San Francisco, 91
Santa Fe, 56, 89
Saraswati, 23–25, 29, 121
Sarkar, Surendra Chandra, 24

sculpture, 12, 14–15, 21–34, 91, 100, 108–16, 121–22
Seagrove, 119
Seljuks, 82
Seto, 91, 97
Seven Gods, 109–12
Shamakali, 22, 26, 28
Shankharibazar, 27–28
Shankharibazar Kali Mandir, 27
Shaw, Simeon, 96
Shields, Ethel, 53–54
Shigaraki, 91
Shimimoto, Chizuko, 96
Shimulia, 32, 120
Shiva, 22–23, 26
Shoki, 110
Sitala, 23
Skåne, 34–36
slip, 30, 48, 58, 106–7
Smithsonian Institution, 36
South Carolina, 39
souvenir, 47, 51, 54, 119
Staffordshire, 96
stoneware, 8, 11–12, 34–47, 98–105, 107–16
storyteller, 53–55
Sudan, 77
Sufism, 33, 86
Süsler Çini, 57–60, 73, 77, 98
Sweden, 34–36, 93, 100, 119

T

Tanti Bazar, 22, 28
Taoism, 111
Tatebayashi, Chinatsu, 95
Tatebayashi, Hirohisa, 13, 92–98, 100, 119
Tatebayashi, Sadao, 89–93, 96
tea ceremony, 101, 103–5
technology, 19–21, 48, 54, 56, 63, 76, 89–90, 94, 96, 102, 105, 111
tiles, 21, 57–58, 61, 78–79, 81
Tokoname, 91

Tokyo, 116
Torivio, Frances, 51, 53–55
tourism, 51, 53–54, 57, 80
toys, 31, 33, 54
tradition, 34, 36, 51, 56, 74, 97
Turkey, 3, 56–94, 96–97, 100, 106–7, 116–17

U

Uji, 102
United States, 8–11, 29, 36–56, 87–90, 118–19
utility, 17, 19, 21, 29–31, 33–34, 39, 41, 47, 105

V

values, 17–18, 29–34, 90
Vienna, 77
Vishnu, 23

W

wabi, 101–5
wheel, 20–21, 36, 58–59, 94, 102, 106–7, 115–16

Y

Yanagi, Soetsu, 91
Yeşildere, Fevziye, 86–87, 89

Z

Zen Buddhism, 101, 105, 107, 112

THE POTTER'S ART
designed by
Henry Glassie
composed by
Bruce Carpenter
published by
Material Culture
and the
Indiana University Press

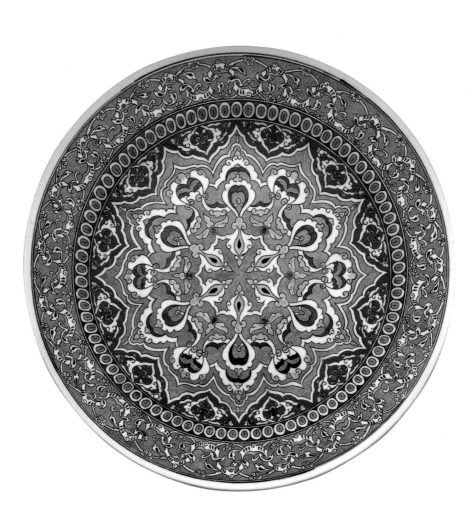